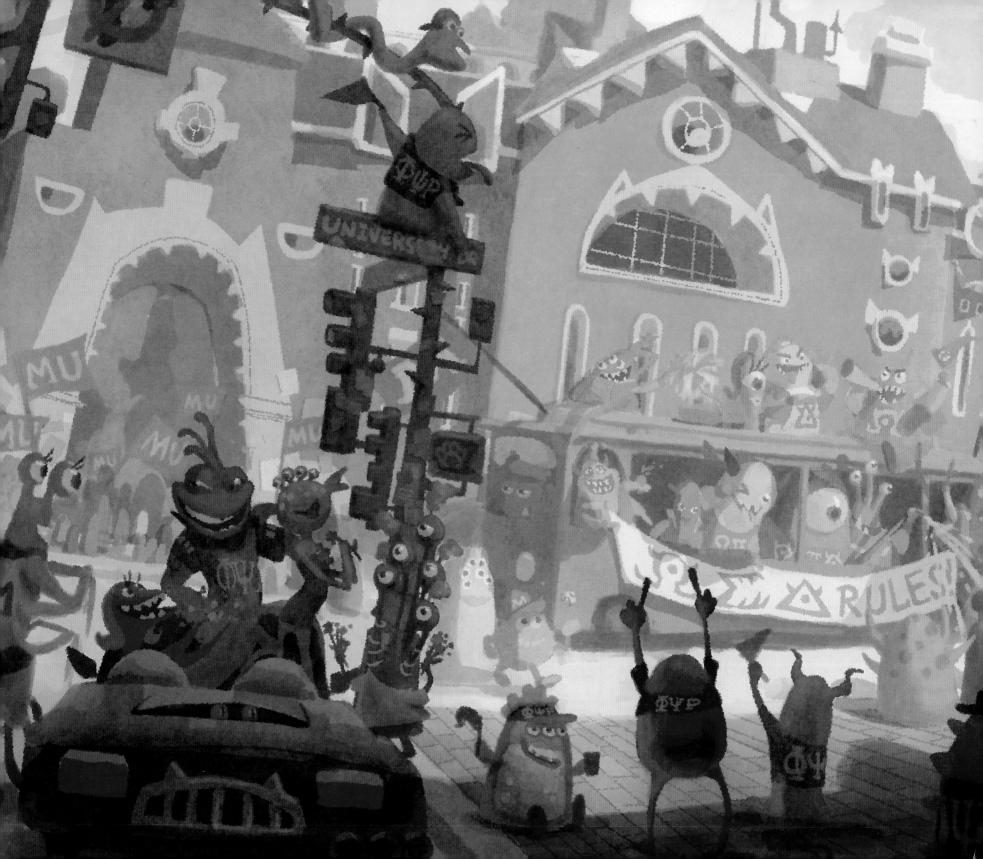

THE ART OF Disney · PIXAR MONSTERS UNIVERSITY

By Karen Paik

Preface by John Lasseter and Pete Docter

Foreword by Dan Scanlon

CHRONICLE BOOKS

SAN FRANCISCO

Library of Congress Cataloging-in-Publication Data:

Paik, Karen.
The art of Monsters university / by Karen Paik ; foreword by Dan Scanlon ;
 preface by John Lasseter and Pete Docter.
p. cm.
ISBN 978-1-4521-1207-7
1. Monsters university (Motion picture)—Illustrations.
 2. Animated films—United States. 3. Pixar (Firm) I. Title.
NC1766.U53M668 2013
791.43'72—dc23

Manufactured in China

Designed by Glen Nakasako, SMOG Design, Inc.

0 9 8 7 6 5 4 3 2

Chronicle Books LLC
680 Second Street
San Francisco, California 94107
www.chroniclebooks.com

front cover image: **Ricky Nierva, Dice Tsutsumi** | gouache, digital | 2012

back cover image: **Jennifer Chang** | digital | 2012

front flap image: **Jason Deamer** | ink, gouache, pen | 2011

back flap image: **Ricky Nierva** | digital | 2010

casewrap image: **Cassandra Smolcic** | digital | 2011

front and back end papers: **Craig Foster** | digital | 2012

page 1: **Shelly Wan** (painting), **Cassandra Smolcic** (design) | digital | 2011

pages 2–3: **Shelly Wan** | digital | 2010

pages 4–5: **Shelly Wan** | digital | 2010

Photograph of John Lasseter on page 6 Courtesy of the California Institute of the Arts Archive.
California Institute of the Arts Library, California Institute of the Arts, Valencia, California.
Credit: California Institute of the Arts Photographic Materials Collection.

CONTENTS

PREFACE

Making a sequel is a huge challenge. You want to create a story that's true to the original characters and film but at the same time take the audience somewhere new and different. Making a prequel proved even trickier. After all, anyone who's seen the original film already knows how this one is going to end! Luckily, the *Monsters University* team studied hard, did their homework, and passed this test with flying colors.

If *Monsters, Inc.* was about what happens when a new and strange door opens, *Monsters University* is about what happens when the door you've been headed toward unexpectedly slams shut. It's a question every one of us has had to deal with at one time or another: What do you do when your dreams run into the roadblocks of real life?

Director Dan Scanlon embraced this concept and made it his own, all the while remaining true to the *Monsters, Inc.* characters and world. Dan's irreverent sense of humor was just the right match for Mike and Sulley, and clicked perfectly with the college setting.

Production designer Ricky Nierva and his frighteningly talented team of artists have created a world for this film that is simultaneously eye-opening and familiar. They've managed to seamlessly merge the monster aesthetic of the first film—the buildings and spaces that accommodate characters of all shapes and sizes, and the monster-y decorative details—with the dignified architecture and raucous crowds of the archetypal collegiate environment.

It was remarkable to watch entirely new aspects of characters and places we knew so well reveal themselves in the hands of these talented filmmakers. In this book you'll see the evolution of their ideas— and some of the most gorgeous art we've ever seen at the studio.

Join us as we walk out the door of the *Monsters Inc.* scare factory and down the streets of Monstropolis.

—John Lasseter and Pete Docter

College-age John Lasseter | 1979

College-age Pete Docter | 1989

John Lasseter | marker | 2009

FOREWORD

College-age Dan Scanlon | 1995

O ur films can take anywhere from four to five years to create. So we often say that, between the time spent and lessons learned, each film is like getting a college degree. They are long journeys of success and failure that can oftentimes lead to life-changing self-discovery. That's why when we decided to tell the story of how Mike and Sulley met, and how they became the characters that audiences fell in love with in *Monsters, Inc.*, college seemed like the perfect setting.

To me this movie is for anyone who has dealt with failure. We all come face-to-face with it at some point in our lives. I love asking friends and fellow Pixar employees how they ended up in their chosen field. More often than not, the story starts with a very different dream. "How did I become an animator? Well it all started in law school . . ." I think it's these missteps and misdirections that make us stronger and make our life's story more interesting. I love movies that inspire us to believe that if we try hard enough, we can be anything we want. The truth is, sometimes as hard as we try, as much as we believe, things just don't work out; it happens to all of us. But in hindsight these "failures" often turn out to be nothing more than detours leading to wonderful discoveries of a life, a career, a love we never would have thought possible.

Developing a story is all about failing over and over again. Every Pixar movie goes through this struggle. When our film's story was struggling, it was the regular escapes to the art department that kept me going. There Ricky Nierva and his team would show me the beautiful art that suggested what the movie could one day become. I'd see paintings that promised great dramatic and emotional possibilities, as well as hilarious character designs, epic sets, and lighting so vivid that even from inside a dark screening room you could smell the grass and feel the breeze on campus. The early animation I reviewed breathed life into characters that we were still just forming on the page. It was these meetings that sent me back to the diligent story-and-editorial team with newfound inspiration for what this fledgling film would one day grow to be.

I'm proud to work with a studio full of these "failures"—failed musicians, failed doctors, failed athletes—each one of us now living a life far different and more wonderful than the one we imagined. We fail together every day, and it only makes us, and our films, stronger.

So please enjoy the work of Pixar's graduating class of 2013.

—Dan Scanlon

John Lasseter | marker | 2009

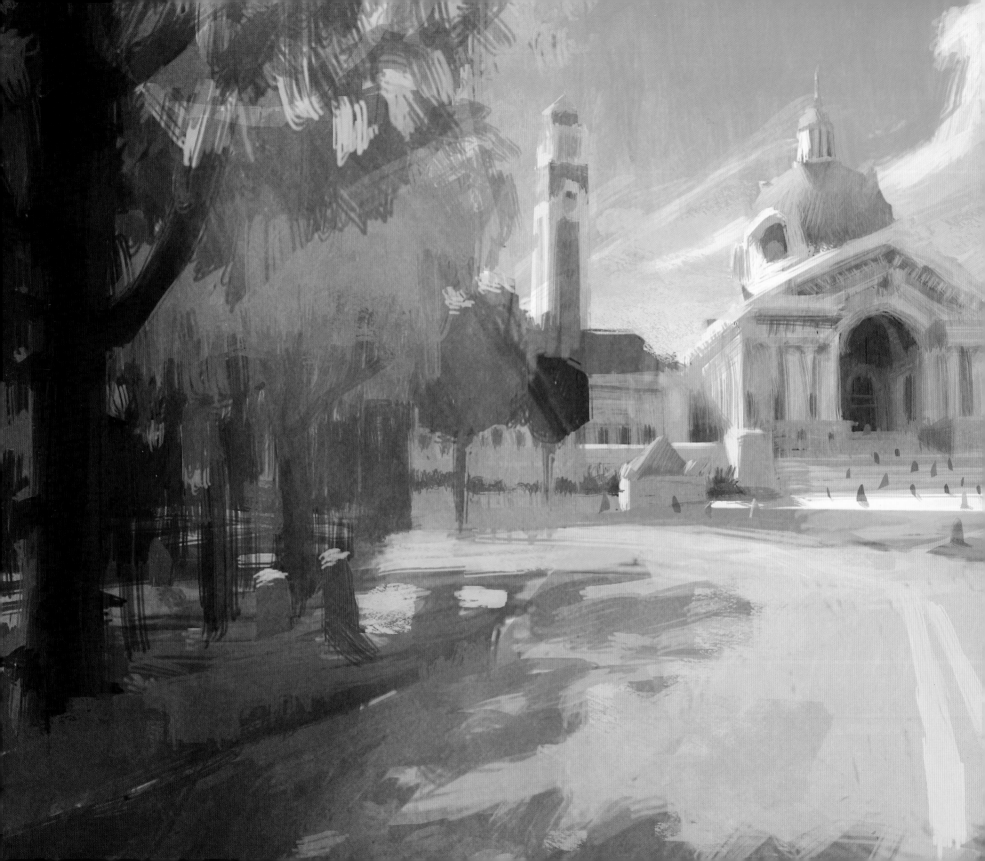

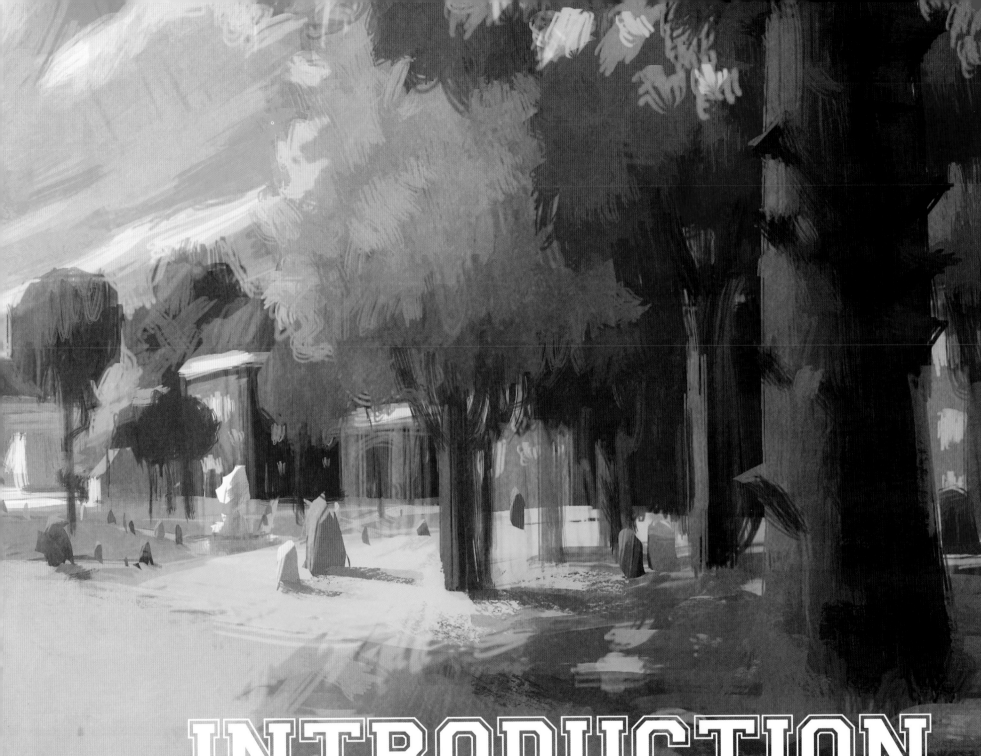

INTRODUCTION

When the idea of a sequel to *Monsters, Inc.* was first discussed, there was only one thing that was off the table for Pete Docter, the director of the original film: It was going to be impossible to bring Boo back. Docter knew that people would want to see the little girl again—even during the making of the first movie, people had wanted to see her in the final scene, not just hear her voice—but he felt strongly that the character's story had ended in the right place.

Instead, it was decided that the new *Monsters* movie should be a prequel, telling the story of how Mike Wazowski and James P. "Sulley" Sullivan met and became friends. The challenge of the film, as with any sequel, was to figure out how to connect the film to its predecessor while simultaneously taking the story, characters, and audience somewhere new. But the fact that this movie would take the audience back in time instead of forward added a new spin to that task. As director Dan Scanlon put it, "Where does the drama come from when you know how the story's going to end?" On a design level, the question became, What are the defining traits of the *Monsters, Inc.* look, and how can those qualities be adapted —and reverse-aged—to suit this new film's setting and story?

The filmmakers' desire to break new ground with this project had its strongest supporter in the person who had created the world. As Scanlon recalls, "Early on I was probably a lot more careful about connecting things to the first movie, and it was Pete Docter who gave me more license to break the rules. That was a big help for me, to have him there saying, 'Give it a try. Don't worry about it.' This is a bigger world, and just seeing more of it is part of the fun."

Life takes you places that you would never expect, and you just have to be open and ready for that.
—Pete Docter, executive producer

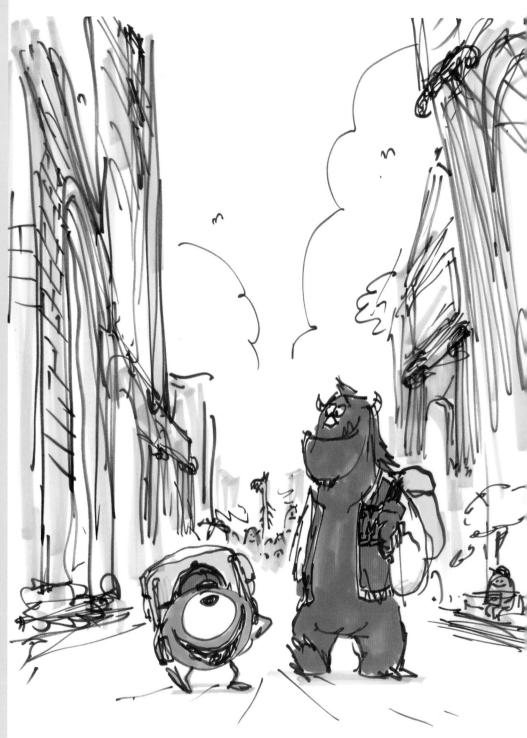

Ricky Nierva | marker | 2008

pages 8–9: **Dice Tsutsumi** (painting), **Matt Aspbury** (pre-visualization) | digital | 2010

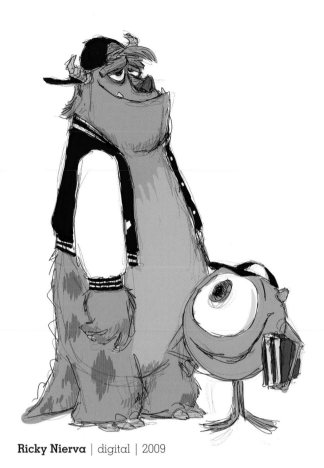

Ricky Nierva | digital | 2009

I think one of the most challenging things at a character level was [determining] whose story this was. We did whole versions of the movie that were Sulley's story, because we felt that Sulley changed the most and learned the most, so by the story gods' law, that meant it was his film. But Mike's story was more interesting. His story—that he originally wanted to be a Scarer himself—was the one we hit on right away and never changed. You knew Mike was headed for failure, but the one thing you didn't know was how he was going to take it. That was the one piece of drama that excited me: You're telling me he loves this so much, but I know it's not going to work out. That's when we decided, forget the story gods on this one. Forget the rules. This feels right, so we're just going to make this Mike's movie.
—Dan Scanlon, director

Monsters, Inc. production designers Bob Pauley and Harley Jessup really laid the foundation of the look. [But where] Monsters, Inc. was celebrating the best of the American workplace, Monsters University [is about] capturing the spirit of the university.
—Ricky Nierva, production designer

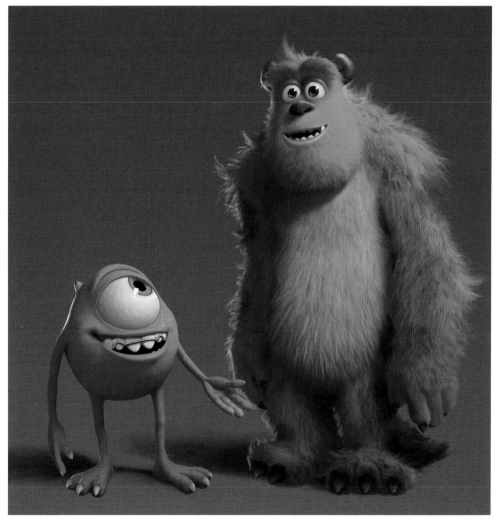

Shelly Wan | digital | 2011

CHARACTER

MONSTERS, INC.

MONSTERS UNIVERSITY

MONSTERS, INC.

MONSTERS UNIVERSITY

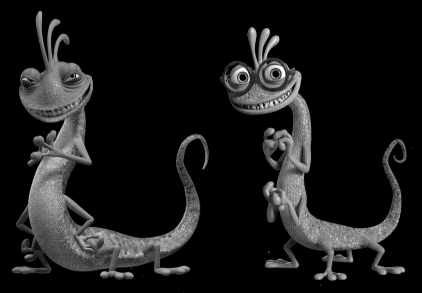

MONSTERS, INC.

MONSTERS UNIVERSITY

When John Lasseter did his first review of the younger versions of Mike and Sulley, as well as Randall and some of the other characters, he urged us to come up with a hook for each of them—something totally obvious that told you these were the characters from Monsters University [and not Monsters, Inc.]. So for Mike Wazowski, the hook was his retainer.
—Ricky Nierva, production designer

SETS

One of the things we did early on was to dive into the first movie and look at what design details they were pulling out for their look. Then we used those principles to help establish the design rules of this film, which we broke into five different areas. The first one, obviously, was the monster-y details: spikes, eyes, and tentacles. The second was the heft of objects—for example, this weighted trapezoid shape that Harley Jessup and Bob Pauley used a lot in the first movie. The third was the functional aspect, the idea that things are built for different-scaled monsters; when Mike and Sulley come out of their apartment in the first film, there's a door within a door. The fourth was the idea that scream power is what powers everything—so you don't have electrical lines as much as you do pipes. And finally, Monsters, Inc. is timeless, but this film should feel like it took place prior to the first one. Period-wise, we wanted to hint at the eighties. Technology in the eighties is larger in scale and squarer in shape compared to the nineties. A good example is if you compare the door stations from the two films. —Robert Kondo, sets art director

MONSTERS, INC.

MONSTERS UNIVERSITY

13

COLOR

The palette and the lighting in Monsters, Inc. is so distinct—we couldn't walk away from that completely, and we wouldn't have wanted to. Dice [Tsutsumi] and Ricky [Nierva] made sure our film was seated in that world from a design and palette standpoint, but they also used the sophistication that we've gained, both technically and artistically, over the last eleven years, to create a look for this film that stands on its own.
—Kori Rae, producer

Dominique Louis | pastel | 2000

Dominique Louis | pastel | 2000

Dominique Louis | pastel | 2000

MONSTERS UNIVERSITY

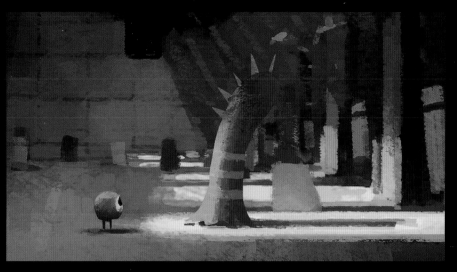

Dice Tsutsumi | digital | 2012

Dice Tsutsumi | digital | 2012

Dice Tsutsumi | digital | 2012

I really wanted to honor the color and lighting that Dominique Louis brought to the first film. The Monsters, Inc. look is theatrical, very saturated, almost a deep ocean atmosphere. This look may have partially been because of technology limitations with early computer animation, but it has a really nice cartoony look. The tools and technology that we have today allow us to achieve incredible realism. However, I wanted to bring back the palette of the first film in combination with our latest rendering tricks, which hopefully brings some of that classic Pixar-film feel to Monsters University.
—Dice Tsutsumi, shading and lighting art director

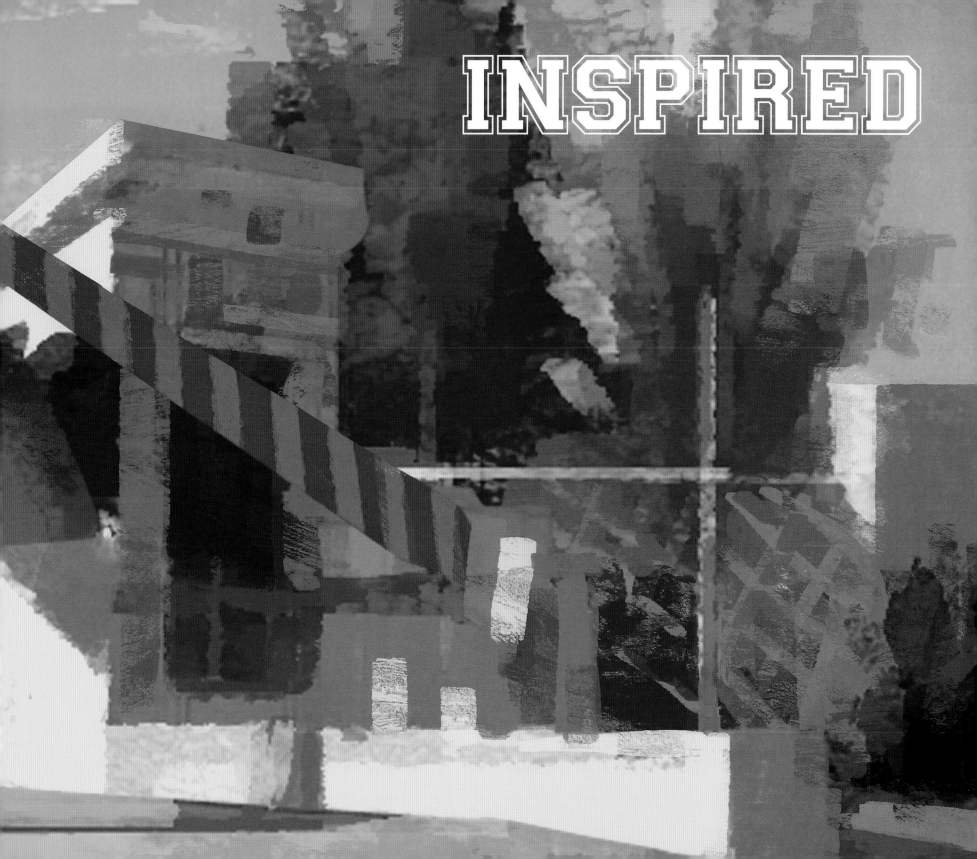

onsters *University* actually begins even earlier than advertised, taking the viewer back more than a decade to Mike Wazowski's childhood and the roots of his dream of becoming a Scarer. "I'm really excited that we're going all the way back to when Mike was in first grade, that we get to see what it means to be a kid monster and how young monsters define themselves," says Dan Scanlon. "There are all these monsters with horns and fur and fangs, but that doesn't mean all monsters are like that. Mike isn't. But at that point in his life, because he's younger, he places all this value on being like those monsters. He's trying to get others' attention, and scaring is the thing that he thinks will do it, especially when he sees how others react to it, and how they value it."

Designing young monsters is a super fun thing to do.
—Jason Deamer, characters art director

Dice Tsutsumi | digital | 2011
pages 16–17: **Dice Tsutsumi** | digital | 2011

FIRST-GRADE MIKE

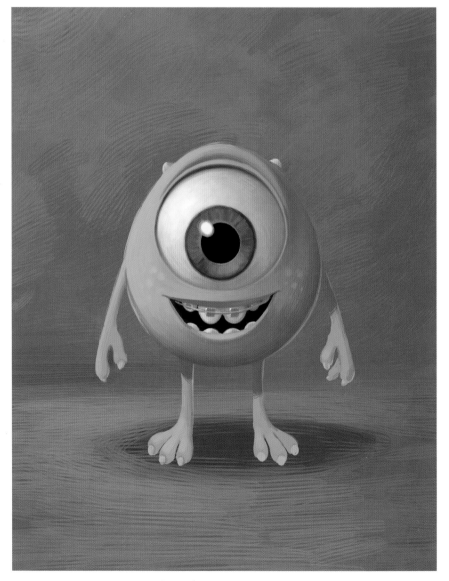

Jason Deamer | digital | 2011

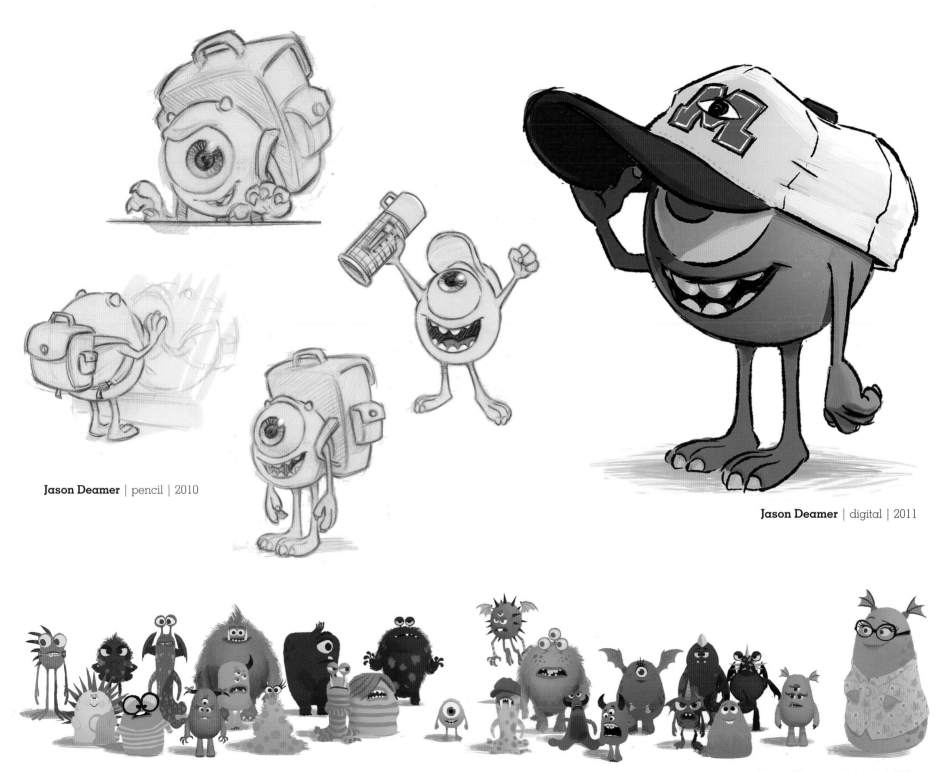

Jason Deamer | pencil | 2010

Jason Deamer | digital | 2011

Jason Deamer | digital | 2011

Dice Tsutsumi | digital | 2011

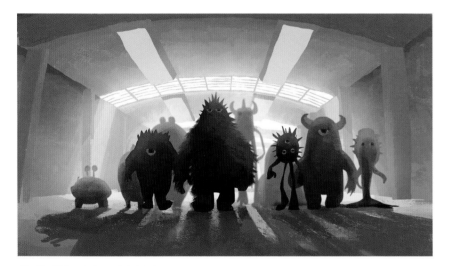

Shelly Wan | digital | 2012

When Mike actually goes in and sees the scare happen, it's great. It's like getting to watch from the dugout when Babe Ruth points to the stands and hits the home run.
—Jeff Pidgeon, story artist

Olivia Nierva | crayon | 2012

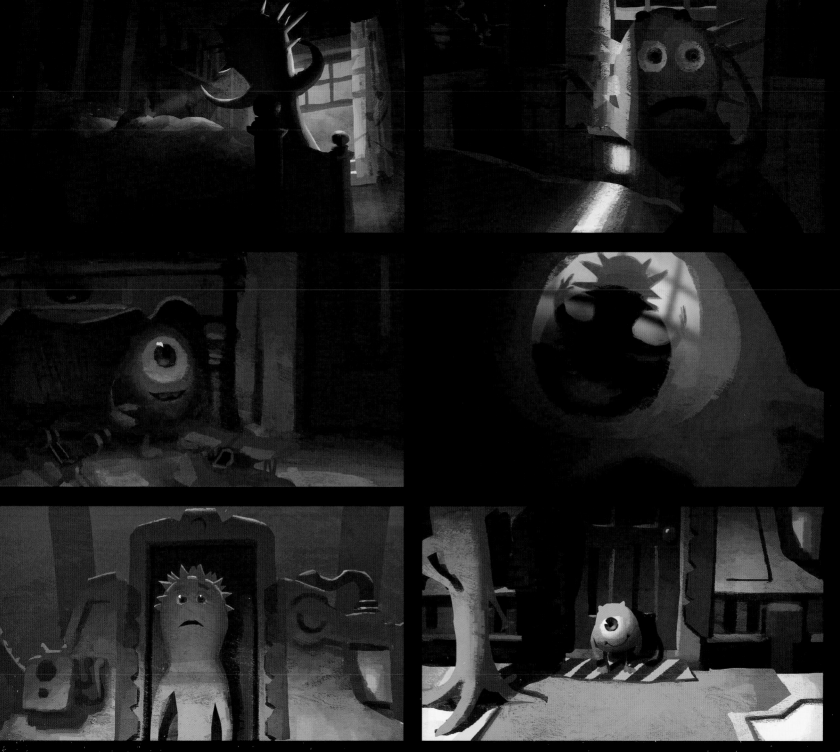

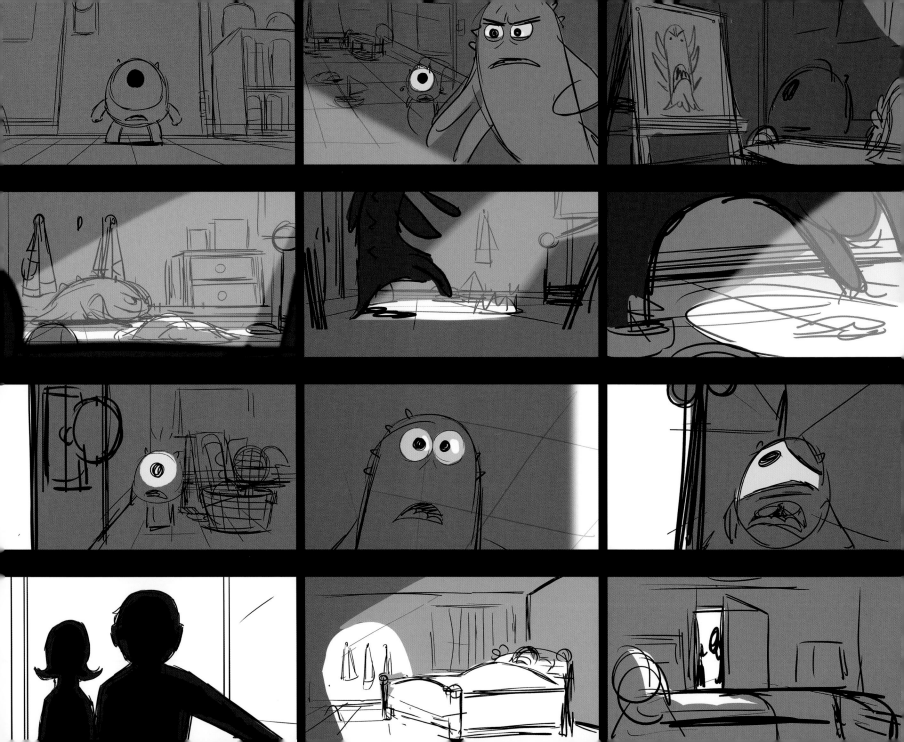

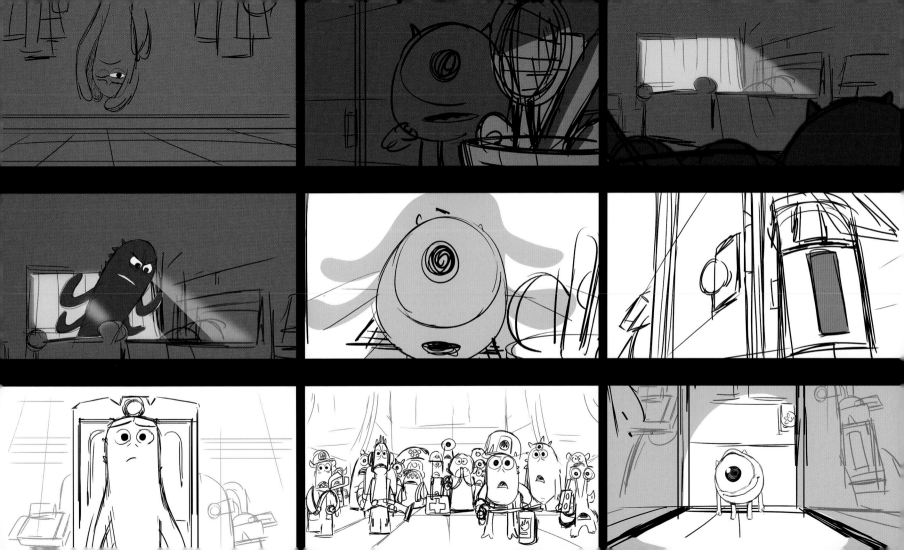

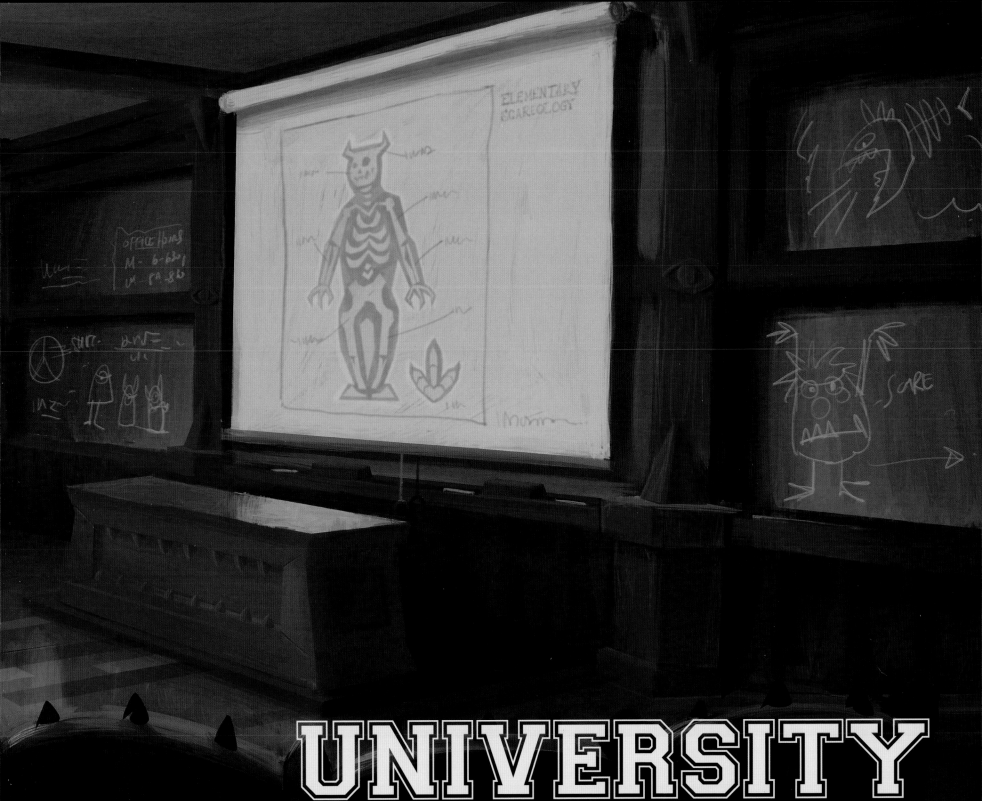

It was at a brainstorming session for non-Boo-related stories, Pete Docter recalls, that the idea of a sequel became the idea of a prequel. "We started kicking around the idea of a university where you learn to scare. And then it went back to the origins of the story: How did Mike and Sulley form this great duo that we saw in the first film? How did that friendship come to be? . . . That was the genesis of *Monsters University*."

"From an emotional point of view," says director Dan Scanlon, "the part of the college experience that worked best for this story was the idea of self-discovery, of figuring out who you are. That felt good right away. College can be a really scary time in your life. There's a lot of pressure." That sincere emotion, however, was nicely counterbalanced by the humor and rich character possibilities of the college setting—a mix that story artist Jason Katz observes fits perfectly with the feel of the original film. "Pete established a tone in the first movie—that the characters are grounded, with real feelings and emotions, but at the same time exist in a universe that doesn't take itself too seriously. I think we've been able to maintain that same tone in *Monsters University*. In the new film, you could have a character going through an identity crisis in one scene, followed soon thereafter by a goofy gag where the same monster gets a Frisbee stuck in his slimy head."

"College is a character in this movie too," says Scanlon, "and once we got the emotional spine of the story working, everyone went crazy coming up with fun college gags. It's great to see how the world opens up when you can see those little true-to-life details and let those background characters sing."

Robert Kondo | digital | 2011
pages 24–25: **John Nevarez** | digital | 2011

COLLEGE MIKE

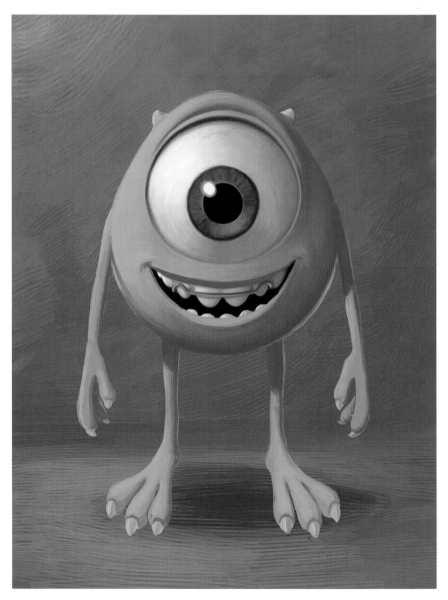

Jason Deamer | digital | 2012

It's not an accident that Oozma Kappa is green. How do you put clothes on Mike? He has no real body. You can put a hat on him, and wrist stuff or leggings, but he can't wear a jacket.
—Jason Deamer, characters art director

Daniela Strijleva | ink | 2009

Jason Deamer | marker | 2008

I remember being asked, How do you make an eyeball look eighteen years old? It's a really good question, but we also see Mike as a little kid. So what does an eyeball look like at eighteen, and what does an eyeball look like at six?
—Ricky Nierva, production designer

 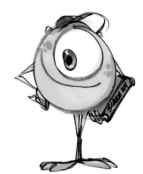 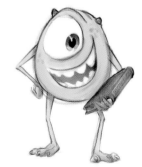

Ricky Nierva | marker | 2010

COLLEGE SULLEY

Daniel López Muñoz | pencil | 2009 **Jeff Pidgeon** | marker | 2008 **Steve Purcell** | marker, pencil | 2008

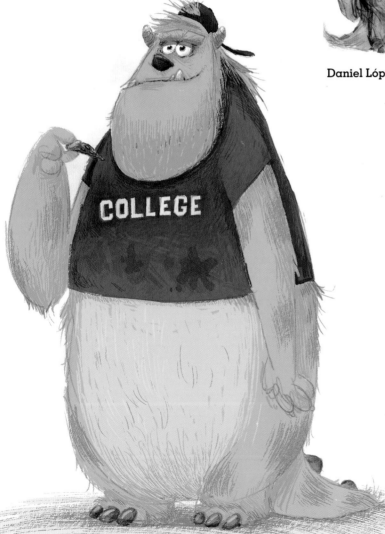

Ricky Nierva | pencil | 2010

Ricky Nierva | digital | 2009

28

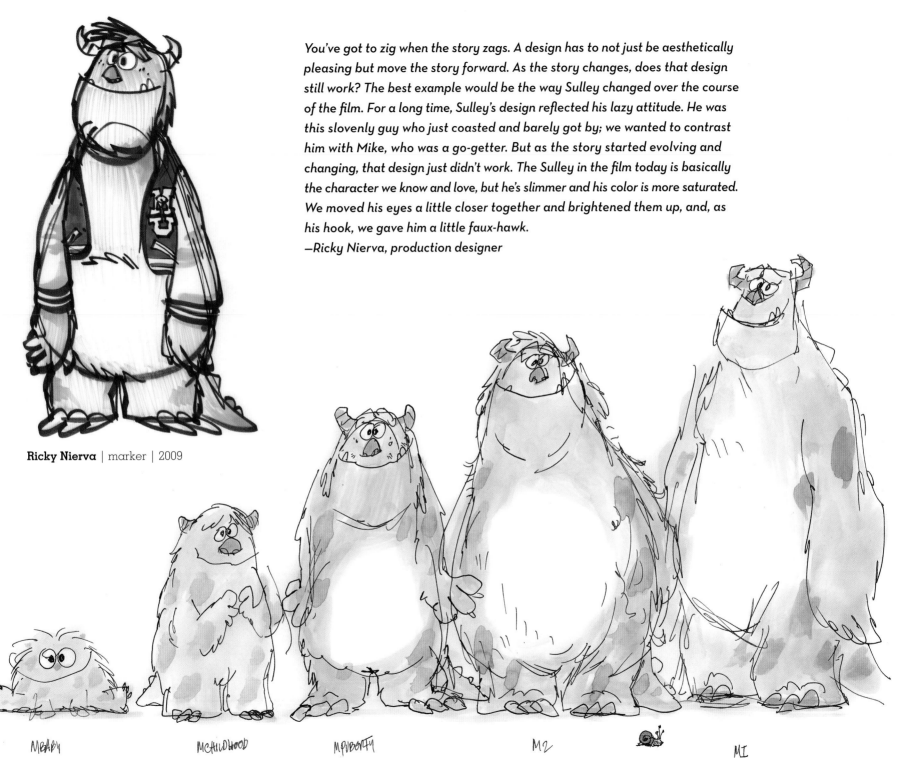

You've got to zig when the story zags. A design has to not just be aesthetically pleasing but move the story forward. As the story changes, does that design still work? The best example would be the way Sulley changed over the course of the film. For a long time, Sulley's design reflected his lazy attitude. He was this slovenly guy who just coasted and barely got by; we wanted to contrast him with Mike, who was a go-getter. But as the story started evolving and changing, that design just didn't work. The Sulley in the film today is basically the character we know and love, but he's slimmer and his color is more saturated. We moved his eyes a little closer together and brightened them up, and, as his hook, we gave him a little faux-hawk.

—Ricky Nierva, production designer

Ricky Nierva | marker | 2009

MBABY MCHILDHOOD MPUBERTY M2 MI

Ricky Nierva | pen, watercolor | 2010

COLLEGE RANDALL

Albert Lozano | paper collage | 2009

Albert Lozano | paper collage | 2009

Daniel López Muñoz | pencil | 2009

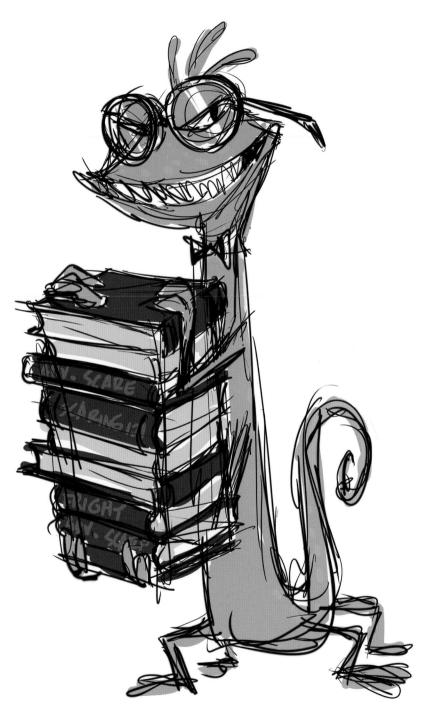

I got to explore a wide range of personalities for Randall, from nice guy to jerk. I did some early explorations of the characters being competitive in school. For instance, Mike, being a know-it-all, would raise his hand, but Randall would one-up him all the time; because Randy's got more hands, he would put up three hands to Mike's one. When Randall became more of a nerdy nice guy, I put glasses on him, to make his eyes bigger. When he takes the glasses off, he starts squinting—which is the look we recognize from the first film.
—Albert Lozano, sketch artist

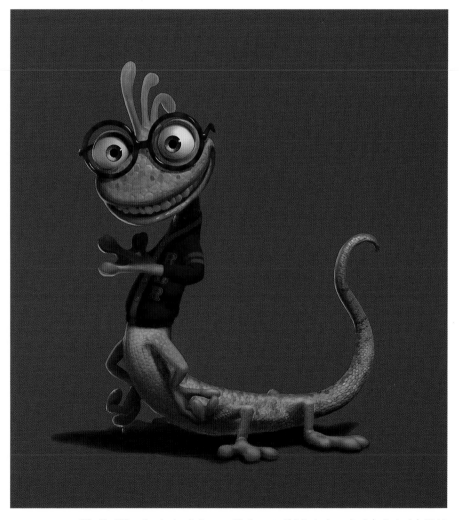

Ricky Nierva | digital | 2009

Shelly Wan (painting), **Jason Bickerstaff** (digital sculpt) | digital | 2011

31

DEAN HARDSCRABBLE

The original version of Hardscrabble had a buglike quality to the face and part of the body, but he was physically massive, like an alligator—heavy and intimidating. When Hardscrabble became a female character, we quickly discovered we couldn't just use the original design. It had to be more specific. She would be more subtle, she would be more elegant.
—Daniela Strijleva, sketch artist

Shelly Wan (painting), **Greg Dykstra** (sculpt) | digital | 2010

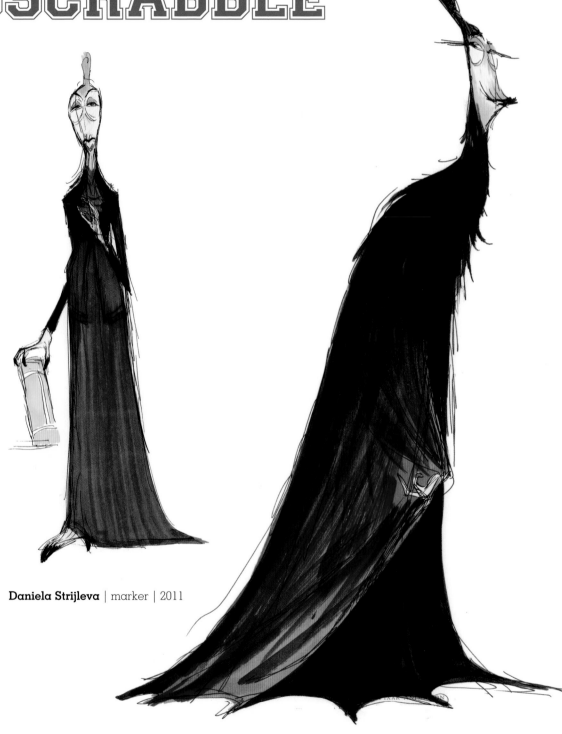

Daniela Strijleva | marker | 2011

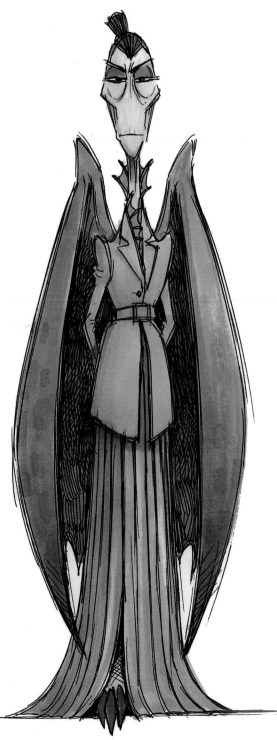

We didn't really have an opportunity in the previous film to see great female Scarers, so Dan thought it would be cool to open up the world and have the most impressive character in our film be a female. Hardscrabble had been designed as a male originally, and at first we didn't think the change would be that difficult. It's the monster world, so the line can be a little more blurry, right? But, that wasn't the case. We literally went back to the drawing board for two to three months of design work, and she turned out to be one of our favorite characters.
—Kori Rae, producer

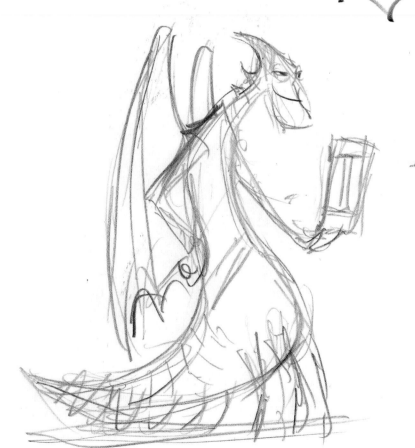

Ricky Nierva | marker | 2012

Jason Deamer | pen, marker | 2012

Dan Scanlon | pencil | 2012

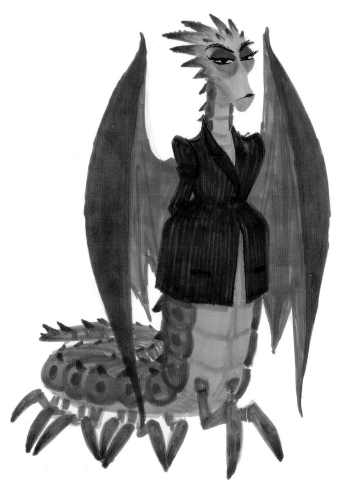

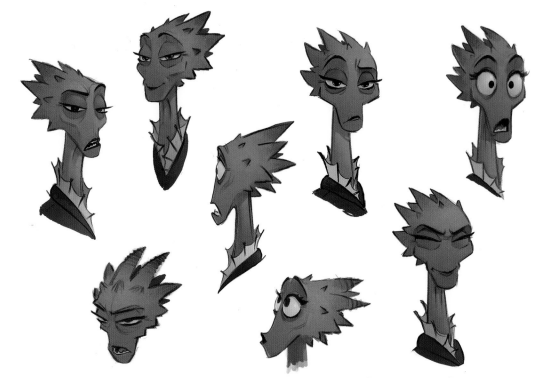

Jason Deamer | pencil | 2012

Jason Deamer | marker | 2012

Hardscrabble is arguably the hardest character I've ever worked on in the fifteen years I've been here. We've had some brainstorms with as many as twelve people working on her. At one point we had four artists working and presenting at the same time on the character.
—Jason Deamer, characters art director

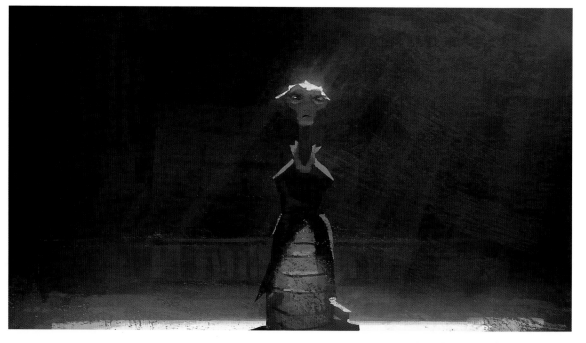

Dice Tsutsumi | digital | 2012

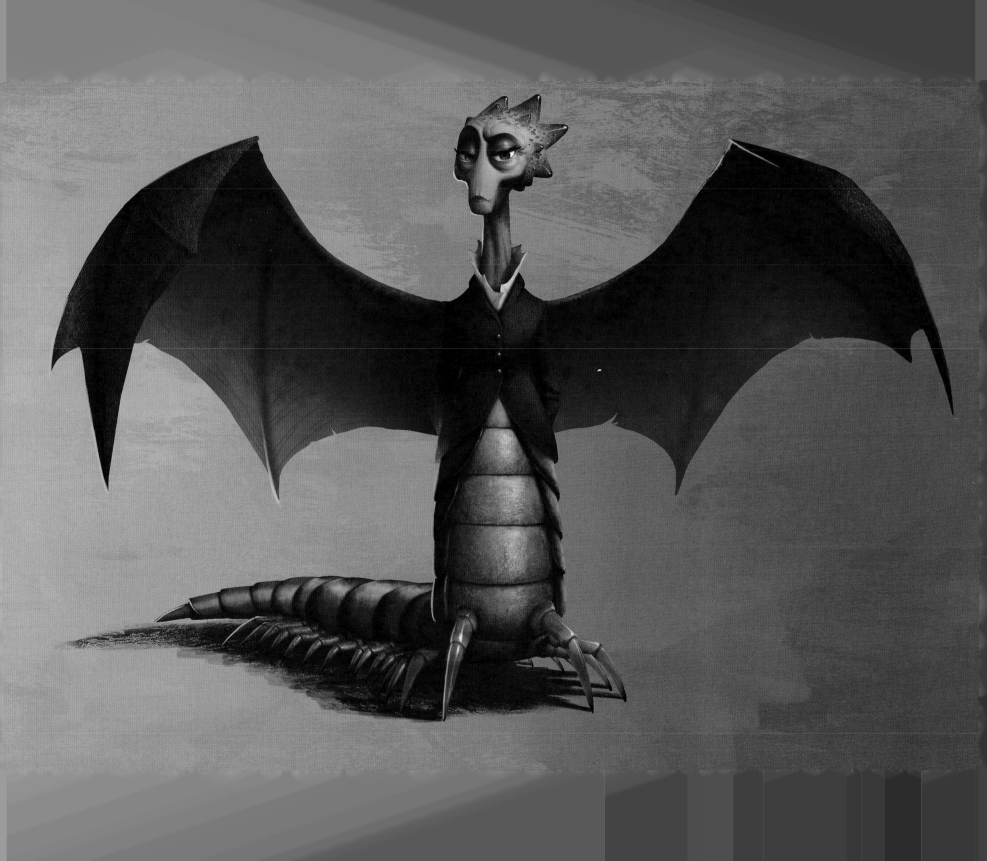

PROFESSOR KNIGHT

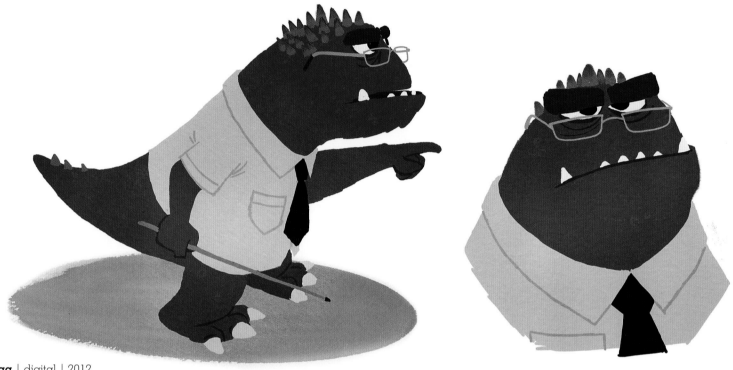

Daniel Arriaga | digital | 2012

Robert Kondo | digital | 2012

Dice Tsutsumi | digital | 2012

PROFESSOR BRANDYWINE

Dice Tsutsumi | digital | 2012

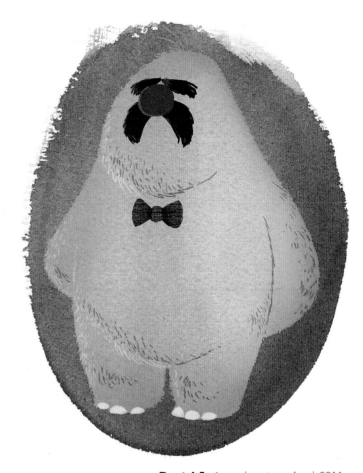

Daniel Arriaga | watercolor | 2011

Storyboards | Brian Fee | digital | 2011

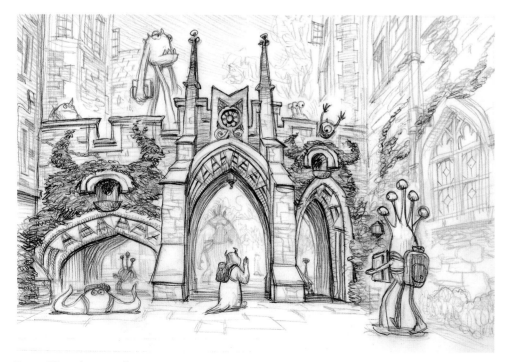

Peter Chan | pencil | 2010

CAMPUS DESIGN

photo: **Doug Sweetland** | 2009

Peter Chan | pencil | 2010

We looked at a lot of schools, and I found that the ones that interested me the most were a little more sprawling, as opposed to the ones that were very structured and squared off. Ricky and I talked a lot about the idea of having rolling hills and curving paths and buildings behind buildings, so that you felt like there was always something around the corner. Because that's what college life is like; that's what being that age is like. You feel like you could do anything, like there's something new wherever you go.
—*Dan Scanlon, director*

It's much more interesting to shoot a set that is not completely flat. A hilly campus gives you great views, great stacking. You have paths that wind around things, and you can really lead the eye and control compositions in a much better way.
—Robert Kondo, sets art director

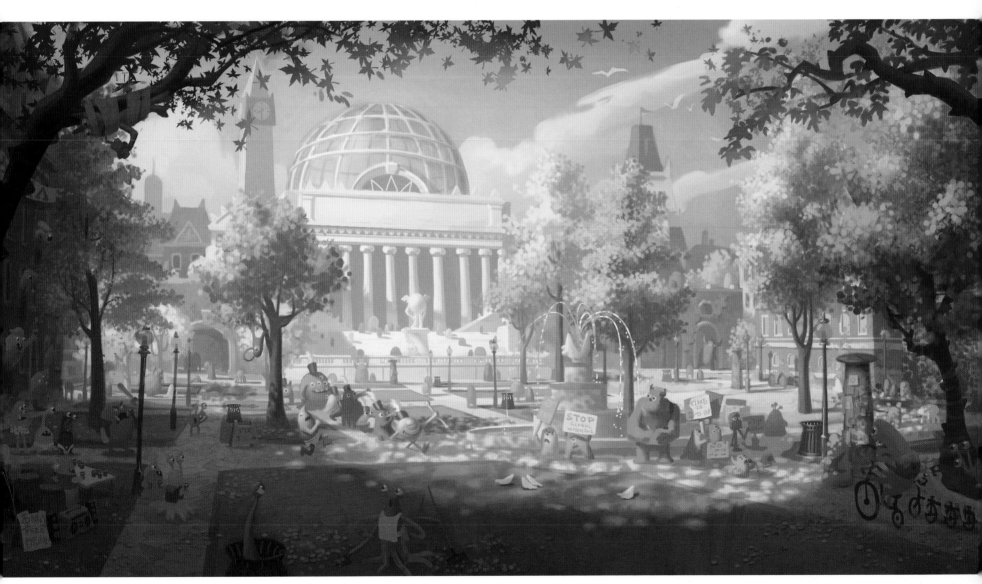

Shelly Wan | digital | 2010

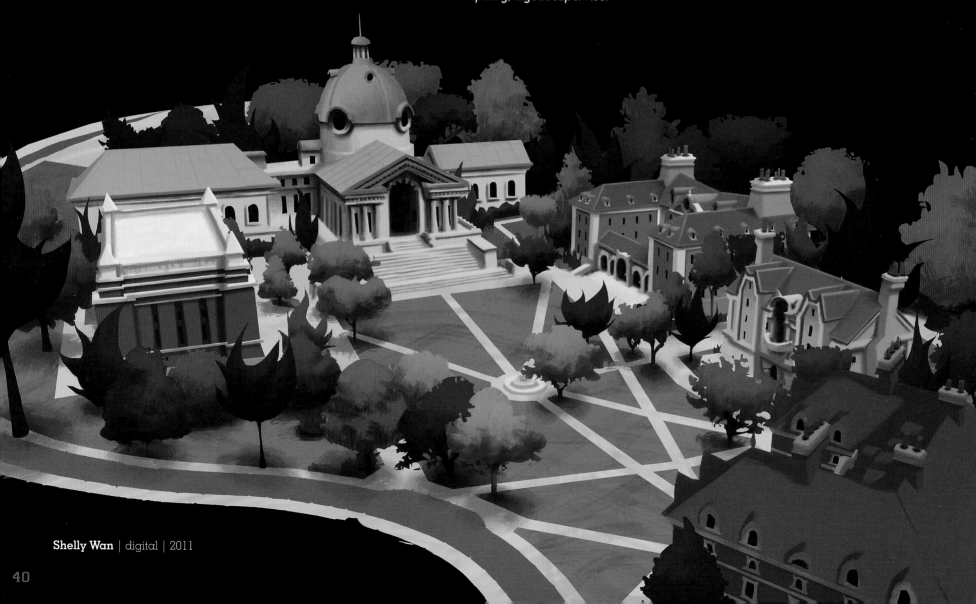

Our initial dilemma was figuring out the right size for the campus. Do we want it to feel like there are these huge monsters on a small campus? Do we want them to dwarf the architecture? Or do we want it the other way around: a monster-size campus where the architecture dwarfs the monsters? We decided that we wanted the School of Scaring to be awe-inspiring and really monumental; the characters should feel overwhelmed by the presence of this building and what goes on in there. Since the School of Scaring is the centerpiece of MU, that pointed us toward making the campus in general a really large one.
—Matt Aspbury, layout supervisor

Shelly Wan | digital | 2011

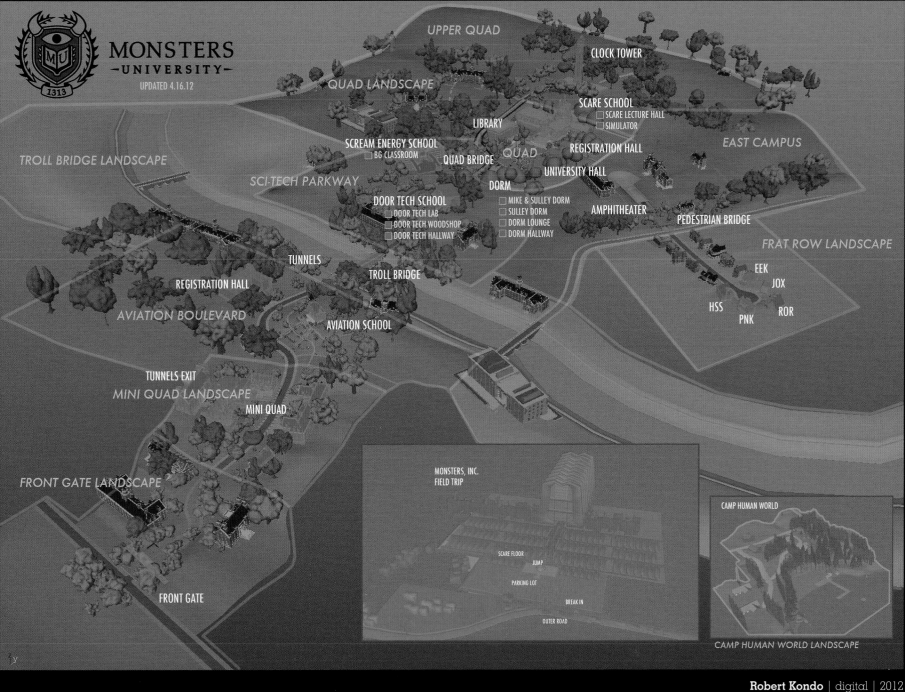

MONSTERS
—UNIVERSITY—
UPDATED 4.16.12

1313

UPPER QUAD

CLOCK TOWER

QUAD LANDSCAPE

SCARE SCHOOL
☐ SCARE LECTURE HALL
☐ SIMULATOR

LIBRARY

TROLL BRIDGE LANDSCAPE

SCREAM ENERGY SCHOOL
☐ BG CLASSROOM

QUAD BRIDGE

QUAD

EAST CAMPUS

REGISTRATION HALL

SCI-TECH PARKWAY

UNIVERSITY HALL

DORM

DOOR TECH SCHOOL
☐ DOOR TECH LAB
☐ DOOR TECH WOODSHOP
☐ DOOR TECH HALLWAY

☐ MIKE & SULLEY DORM
☐ SULLEY DORM
☐ DORM LOUNGE
☐ DORM HALLWAY

AMPHITHEATER

PEDESTRIAN BRIDGE

TUNNELS

TROLL BRIDGE

FRAT ROW LANDSCAPE

REGISTRATION HALL

EEK

JOX

AVIATION BOULEVARD

AVIATION SCHOOL

HSS

PNK

ROR

TUNNELS EXIT

MINI QUAD LANDSCAPE

MINI QUAD

MONSTERS, INC.
FIELD TRIP

FRONT GATE LANDSCAPE

SCARE FLOOR

JUMP

PARKING LOT

BREAK IN

OUTER ROAD

CAMP HUMAN WORLD

FRONT GATE

CAMP HUMAN WORLD LANDSCAPE

Chris Sasaki | marker | 2011

Mark Oftedal | digital | 2010

Shelly Wan (painting), **Nelson Bohol** (design) | digital | 2010

Shelly Wan (painting), Albert Lozano (design) | digital | 2010

Albert Lozano | digital | 2010

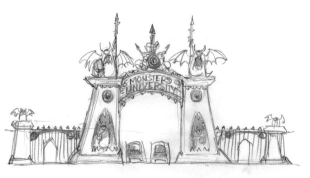

John Nevarez | pencil | 2011

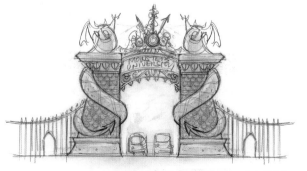

John Nevarez | pencil | 2011

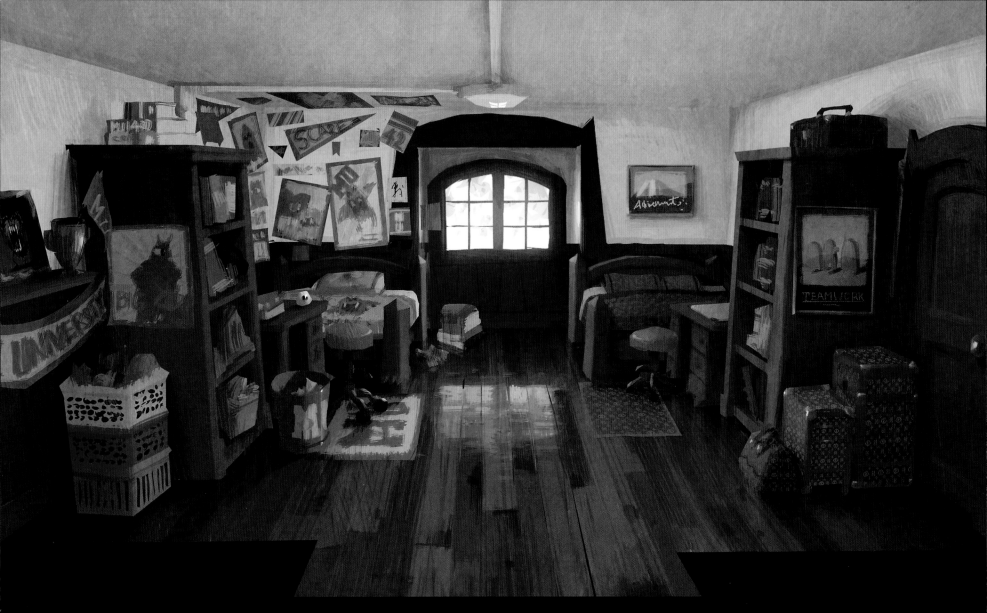

Dice Tsutsumi (painting), **Nelson Bohol** (design) | digital | 2011

For the dorms, we wanted [to evoke] everyone's idea of a dorm. For people who had gone to college and stayed in a dorm, we wanted them to think, Oh my gosh, that's totally like the dorm I lived in. And for people who hadn't had the experience of going to college or living in a dorm, we wanted them to think, I bet that's totally what it's like. We went with an older design for the building because we thought it was important to always remind you of the tradition of the school, and the intimidation of living up to that tradition and rich history.

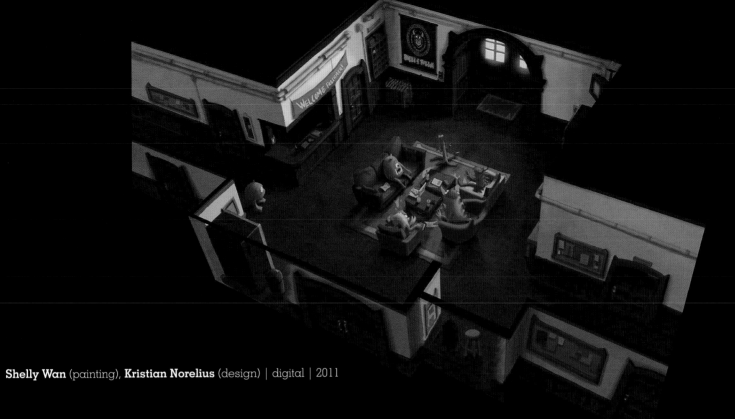

Shelly Wan (painting), Kristian Norelius (design) | digital | 2011

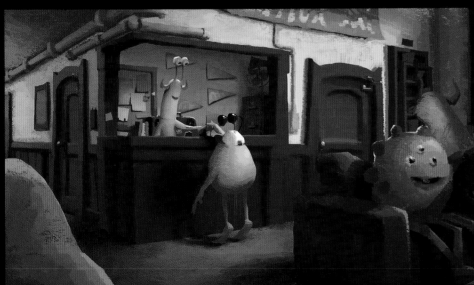

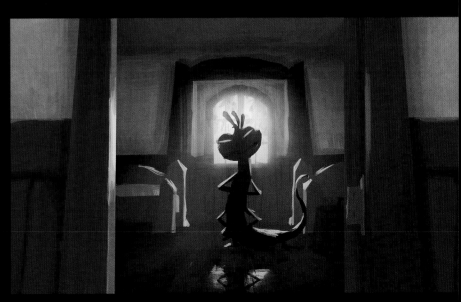

Shelly Wan | digital | 2012

Dice Tsutsumi | digital | 2011

Jennifer Chang | digital | 2012

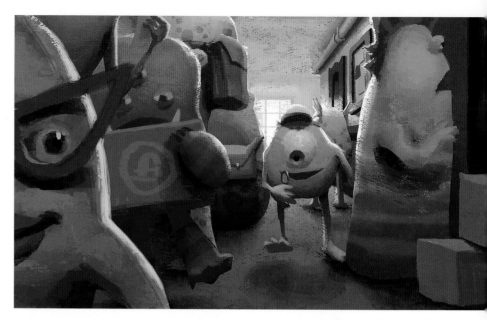

Shelly Wan | digital | 2012

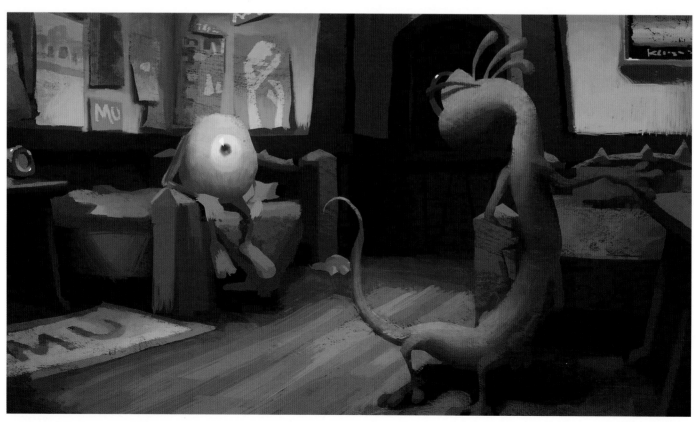

Shelly Wan | digital | 2012

46

FRIGHTENING
FRANK
McCAY

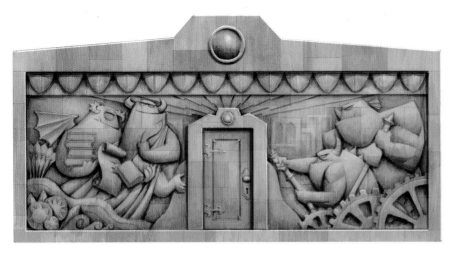

Paul Abadilla (painting), Ricky Nierva (design) | digital | 2011

We also had this area that Sets called the Sci-Tech Parkway, which is where we had a scream energy school and a door tech school. So those buildings are newer, designed maybe in the '70s or the '60s, with concrete paths and landscaped terraced hills. Some of the tree growth is a little younger. It's a subtle thing. The vegetation is thinner than in the Quad, and you see a lot more concrete faces and stone walls. We wanted the viewer to see different aspects of MU as Mike journeys from the front gate deeper into the school.
—Robert Kondo, sets art director

Kristian Norelius | pencil | 2011

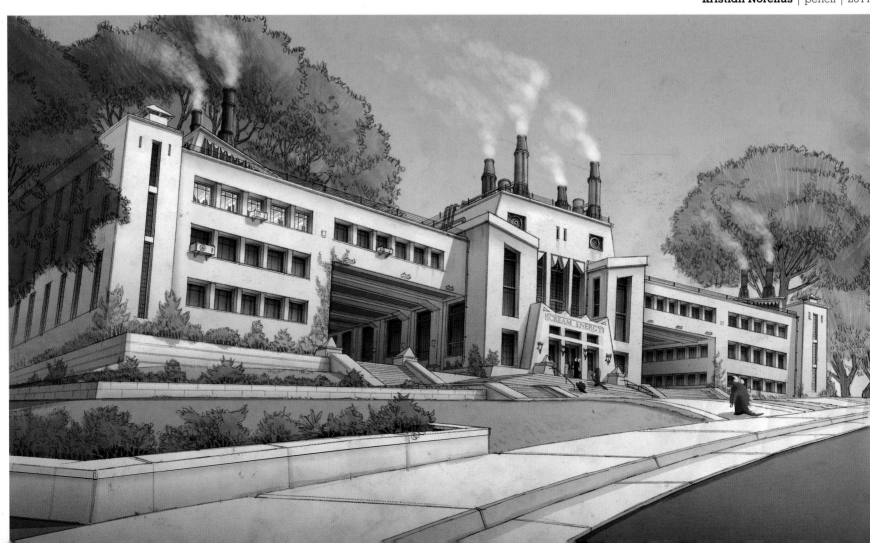

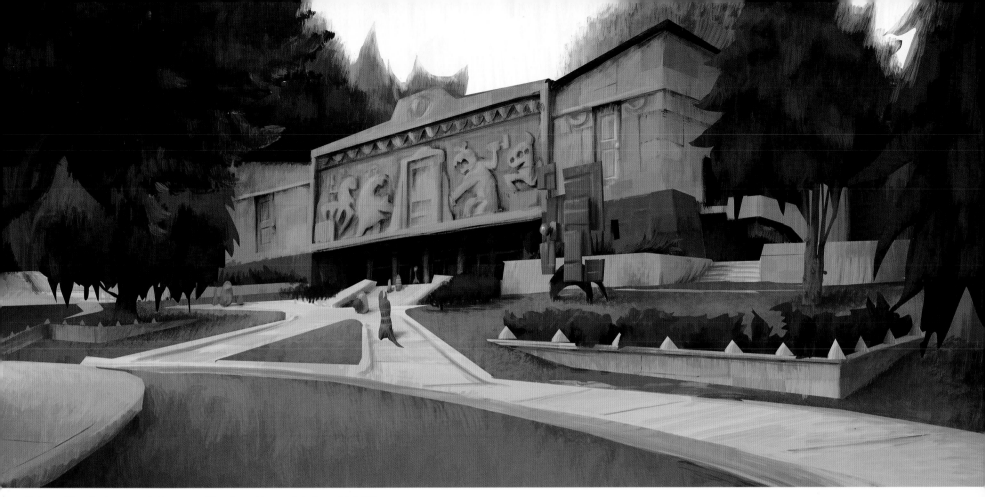

Robert Kondo (painting), **Kristian Norelius** (design) | digital | 2011

Getting to see more of the monster world is part of the fun of this film. A big thing that we were able to do this time around was expand the range of monsters, flying monsters, and underwater monsters and that type of thing. We wanted to show those new monsters right out of the gate, because that's what you see when you get to college. You see different types of people.
—Dan Scanlon, director

Robert Kondo (painting), **John Nevarez** (design) | digital | 2012

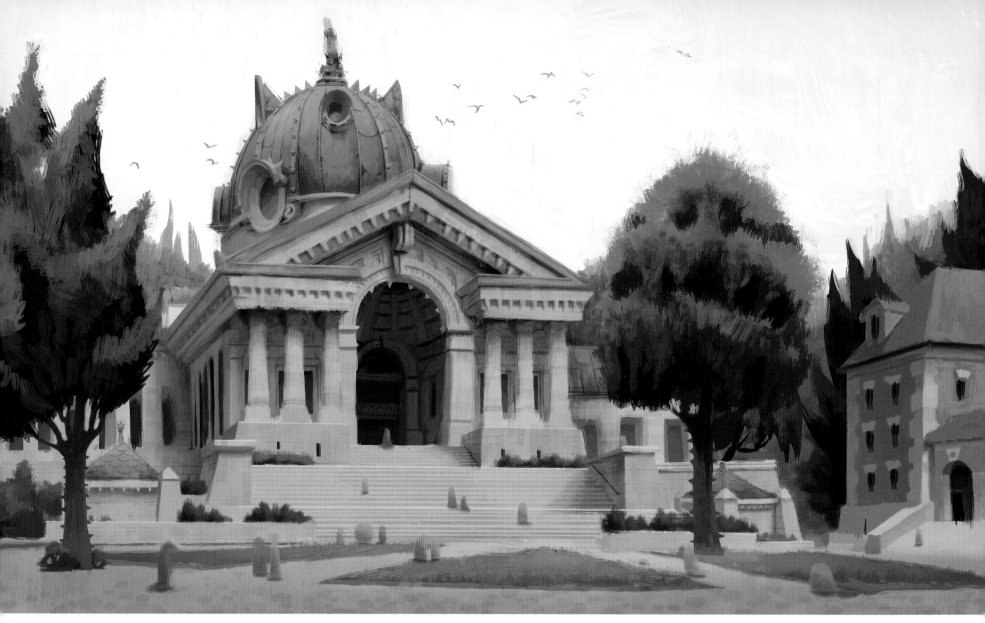

Shelly Wan (painting), Robert Kondo (design) | digital | 2011

The School of Scaring had to be the jewel of the campus, the most beautiful building in the university. It's the one the monster kids would point out to their parents on tours, or that university tour guides would brag about. It would also be the oldest building on campus, because that's how the whole place got started—it would be the heart and soul of the school.
—Ricky Nierva, production designer

Robert Kondo | digital | 2011

Robert Kondo | digital | 2012

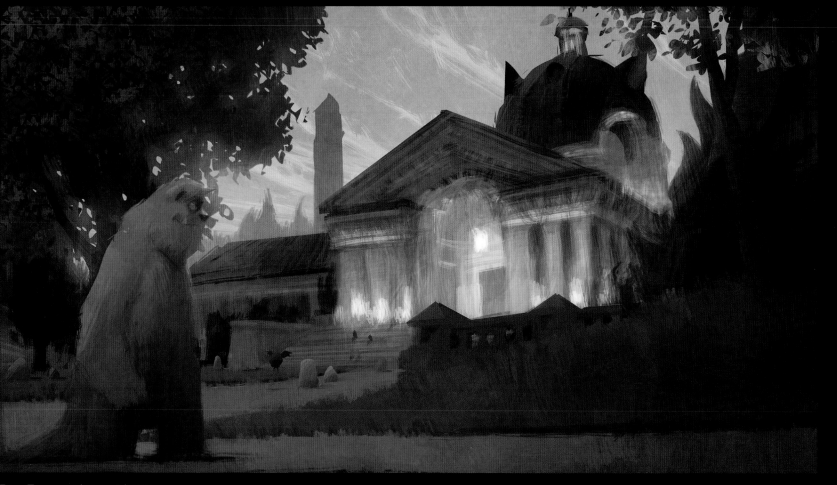

Dice Tsutsumi | digital | 2011

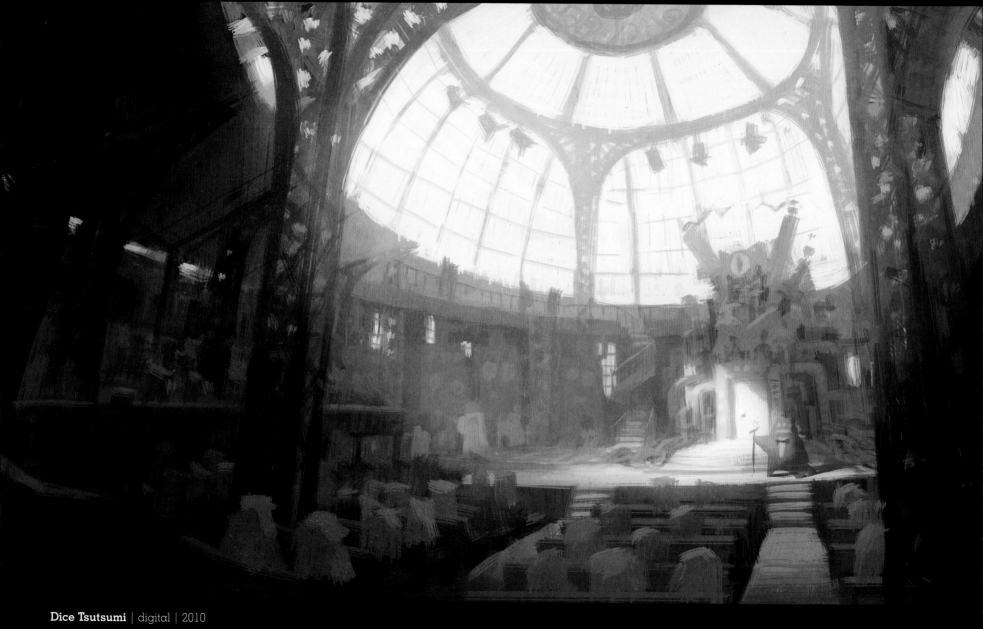

Dice Tsutsumi | digital | 2010

Robert Kondo | pencil | 2011

Robert Kondo | digital | 2012

The great thing about designing sets is that we have the freedom to invent an idea behind a set, an implied history that adds to the richness of the story. We're designing a feeling. The School of Scaring classroom is the center of so many things—it's where all these different characters come together. It represents what Mike loves, what Sulley loves. It represents what Hardscrabble has worked for all her life. It's the tradition of scaring manifested.

—Robert Kondo, sets art director

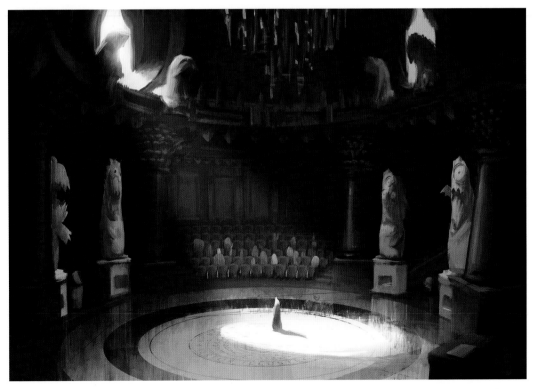

Robert Kondo | digital | 2011

COLLEGE LIFE

When you walk through a college campus, what do you see? Kids are riding bikes and skateboards. There are grassy areas where people lounge around, studying, sleeping. There are couples hanging out, people playing Frisbee, self-important guys playing guitars, all these different clubs. It's fascinating to see all the personalities, and we really tried to capture that richness in the film.
—Scott Clark, animation supervisor

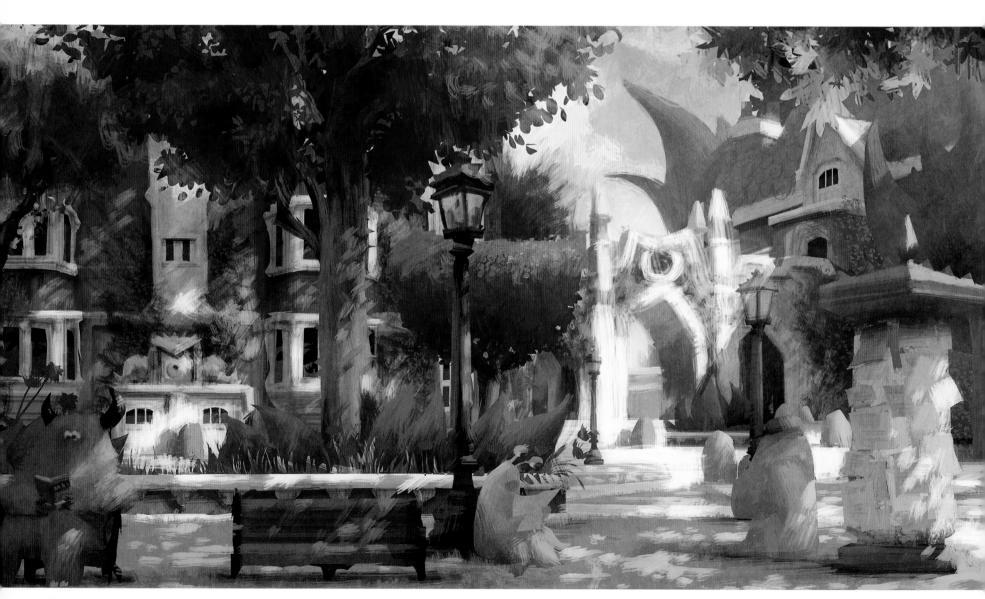

Dice Tsutsumi (painting), **John Nevarez** (layout) | digital | 2011

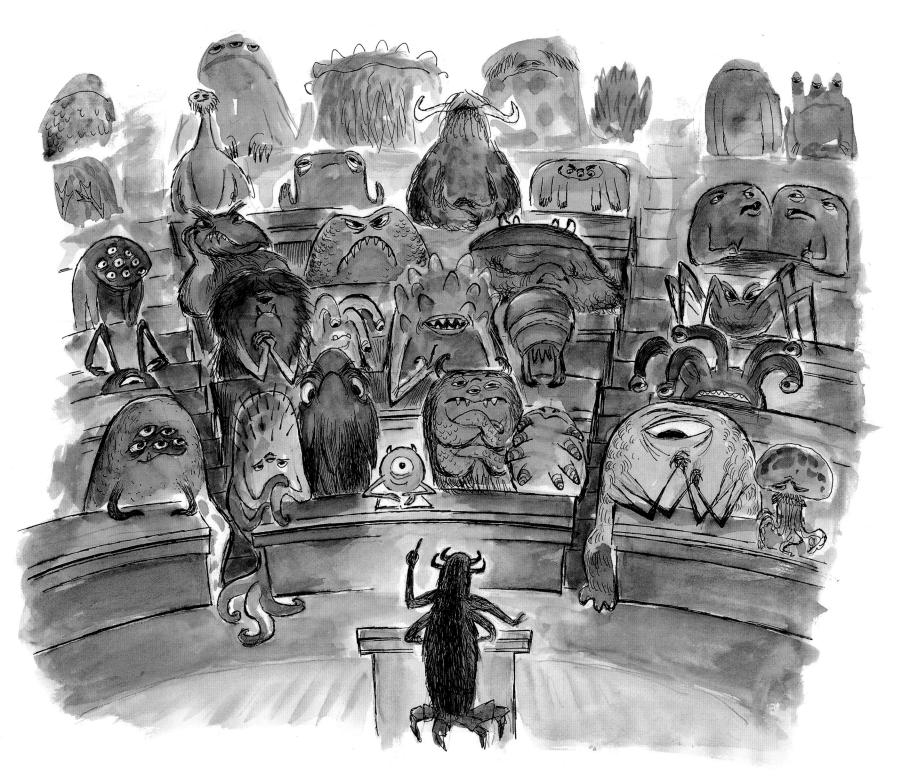

Daniela Strijleva | pen, watercolor | 2009

BiGFOOT'S BiCYCLE

GODZILLA'S BiCYCLE

SQUEAK

FOLDING A NON-FOLDING BiCYCLE

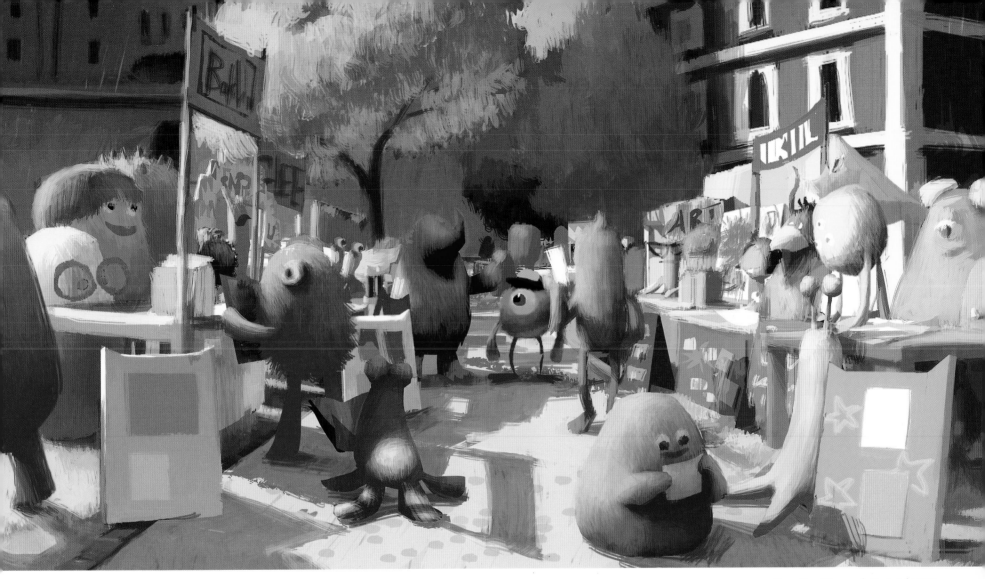

Jennifer Chang | digital | 2012

Manny Hernandez | digital | 2011

57

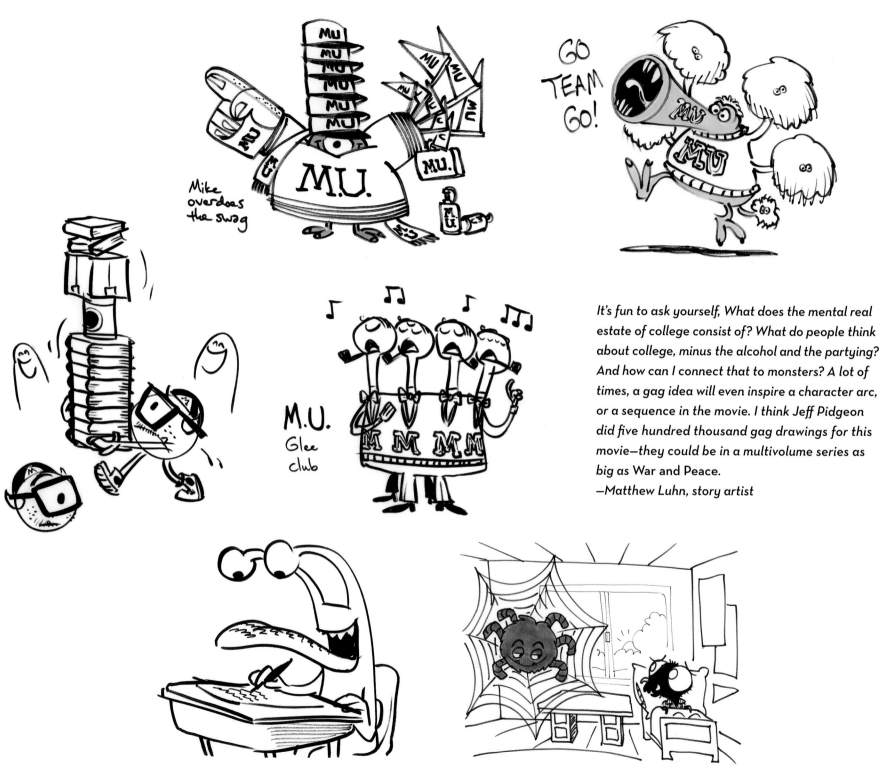

Mike overdoes the swag

GO TEAM GO!

M.U. Glee club

It's fun to ask yourself, What does the mental real estate of college consist of? What do people think about college, minus the alcohol and the partying? And how can I connect that to monsters? A lot of times, a gag idea will even inspire a character arc, or a sequence in the movie. I think Jeff Pidgeon did five hundred thousand gag drawings for this movie—they could be in a multivolume series as big as War and Peace.
—Matthew Luhn, story artist

Jeff Pidgeon | marker | 2009

Kelsey Mann | digital | 2009

The thing that's great about working on gags for a monster film is that you don't have as many boundaries. If you're making a movie about dogs, you have limitations in terms of what a dog can physically do. In this world, if you have an idea for something, you can just say, "Well, let's make up a monster that does exactly that." You can have flying monsters and swimming monsters and fire-breathing monsters and teeny-tiny crawling monsters. You can just go nuts and have whatever you want. That's one of the most fun and liberating things about this world for me.
—Jeff Pidgeon, story artist

Sully uses Mike scare cans to drink ooze soda from

Teddy Newton | marker | 2008

Monsters University traditions

Matthew Luhn | digital | 2009 & 2010

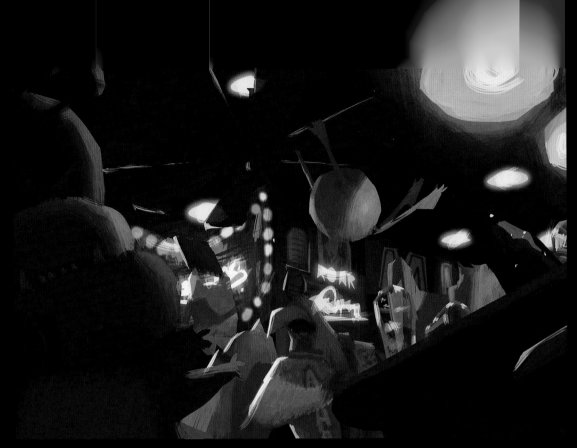

Dice Tsutsumi | digital | 2011

In Story we board a lot of scenes that don't make it into the final film. "Bar Fight" was one of those scenes; Sulley and Mike lead the OK monsters in a cartoony Animal House campus brawl. It was fun storyboarding the essentials to a bar fight, like food flying, eye poking, and food tray head blows. The purpose of the scene was to show Sully, Mike, and the OK monsters bonding.
—Matthew Luhn, story artist

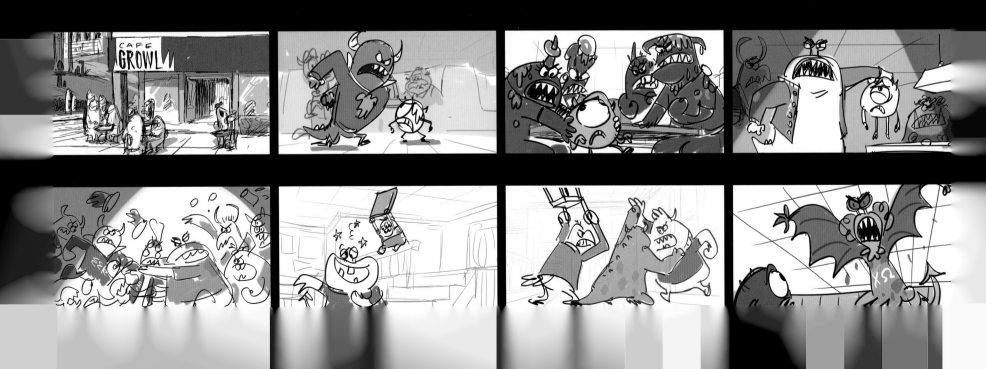

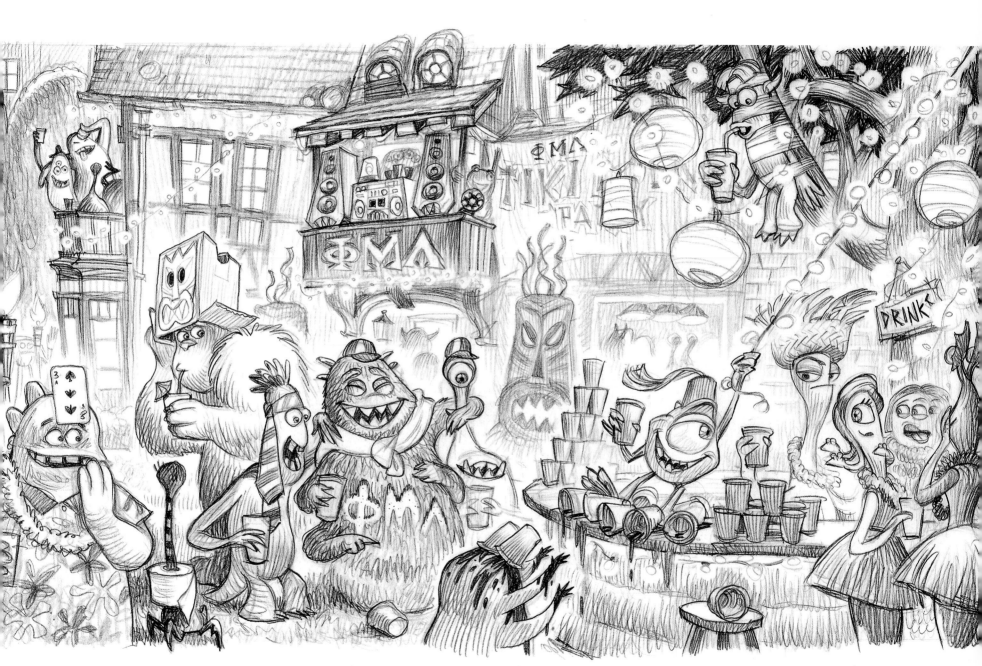

Peter Chan | pencil | 2010

Chris Sasaki | digital | 2010

Albert Lozano | paper collage | 2010

Jason Deamer | marker | 2008

One of the biggest challenges about this film is the variety of character designs. If you look at a film like, say, Ratatouille, there's a wide range of designs in there as well, but there are certain basic rules for how all humans and rats move. But here, the way Art and Terri & Terry and Randall and Hardscrabble move? Completely different body languages. Totally different rules. The rigs are all different. There are some similarities here and there, but how you choose to animate the controls to get the right effect is totally different from character to character.
—Robert Russ, directing animator

Mark Oftedal | digital | 2010

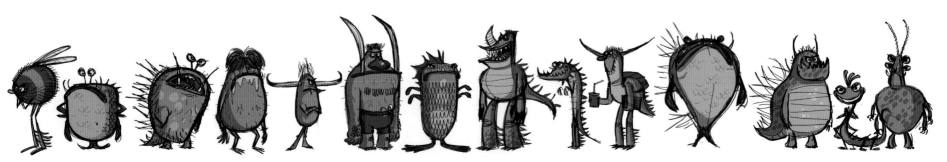

Chris Sasaki | marker | 2010

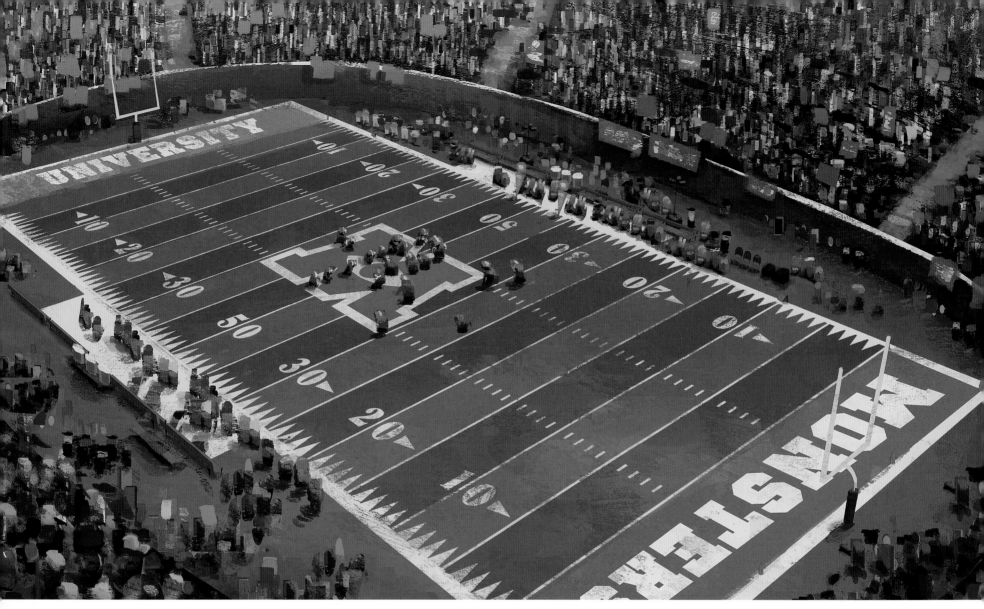

Robert Kondo | digital | 2012

The number of monsters needed to populate the campus is significant.
And the thing with monsters is that you need a lot of species variety.
These are organic creatures who all need different numbers of limbs,
different kinds of limbs, different numbers of eyes, and so forth. We
couldn't go crazy and invent seventy-five brand-new species. So we
tried to be clever about it and take ten different base species and
create variations within each species.
—Sanjay Bakshi, supervising technical director

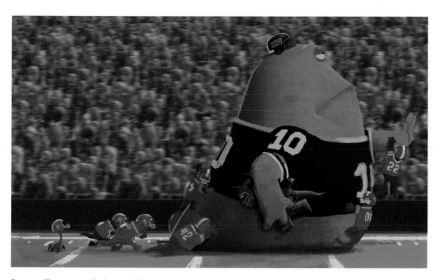

Jason Deamer | digital | 2012

Jason Deamer | marker, watercolor | 2012

SWAMP THING Cheerleader

Mark Oftedal | digital | 2010

Mark Oftedal | digital | 2010

FUNGUS

SLUG

CHARLIE

BLOCK

SPIF

PILL

ONE-OFFS

BACKGROUND CHARACTERS

Historically, we scramble to put together background characters near the end of a production. But early on, we had story changes that affected how many principal characters we could start building. So our technical team decided to front-load the work on our background characters, since we knew we would need them to populate the campus no matter what. We ended up with this unbelievably robust and entertaining stable of background characters—more than three hundred different characters based on ten different templates. And because we had this great pool of characters who were already built, they started to be cast for some of the featured gags.
—Adam Burke, crowds animation lead

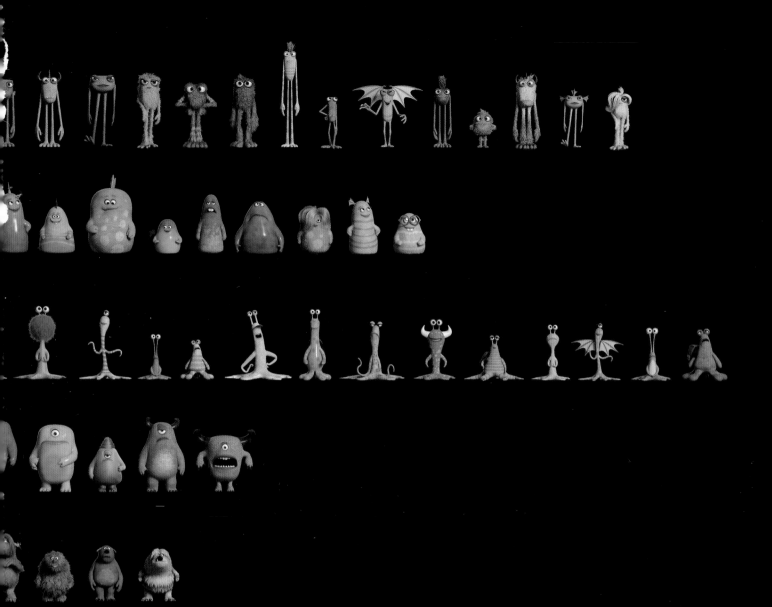

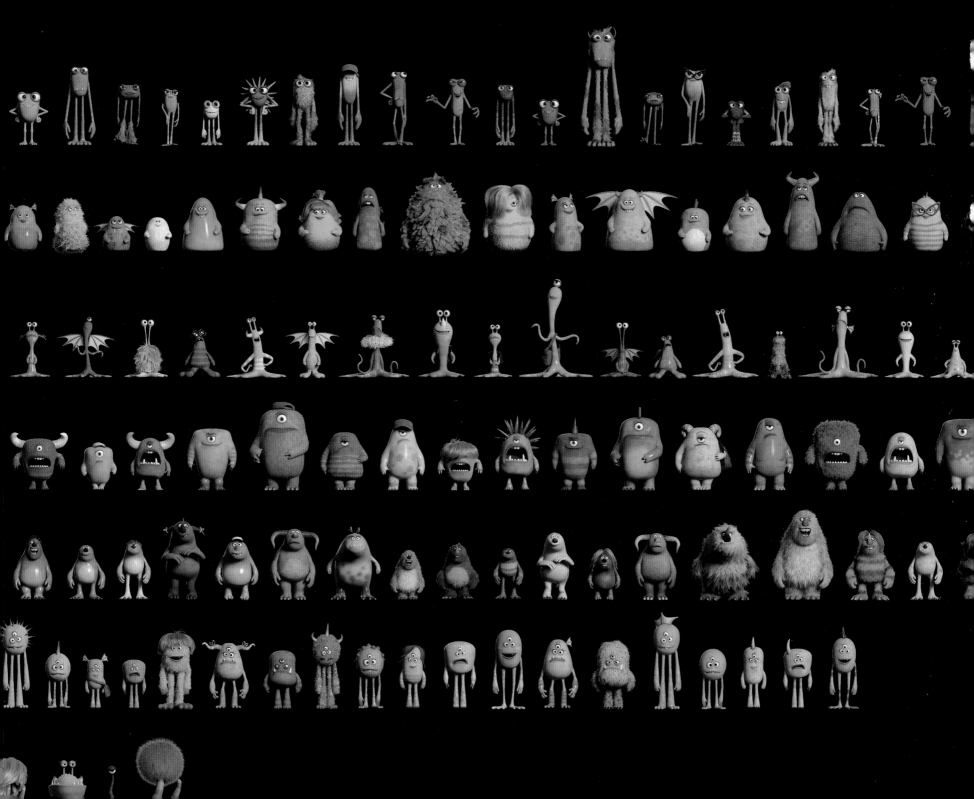

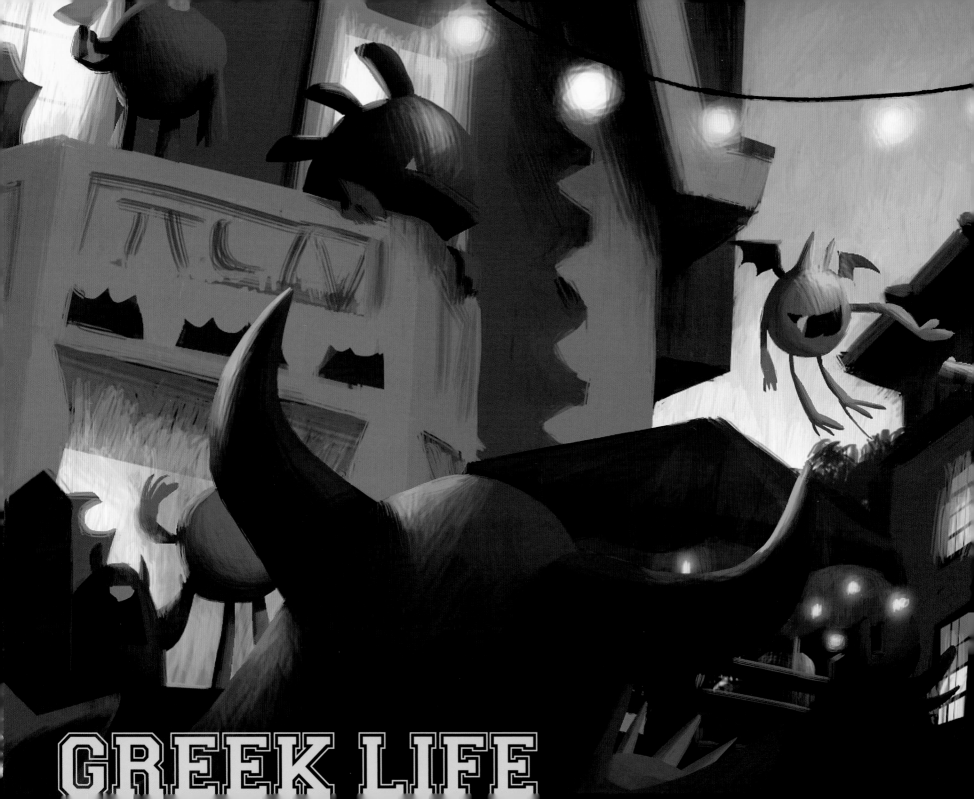

GREEK LIFE

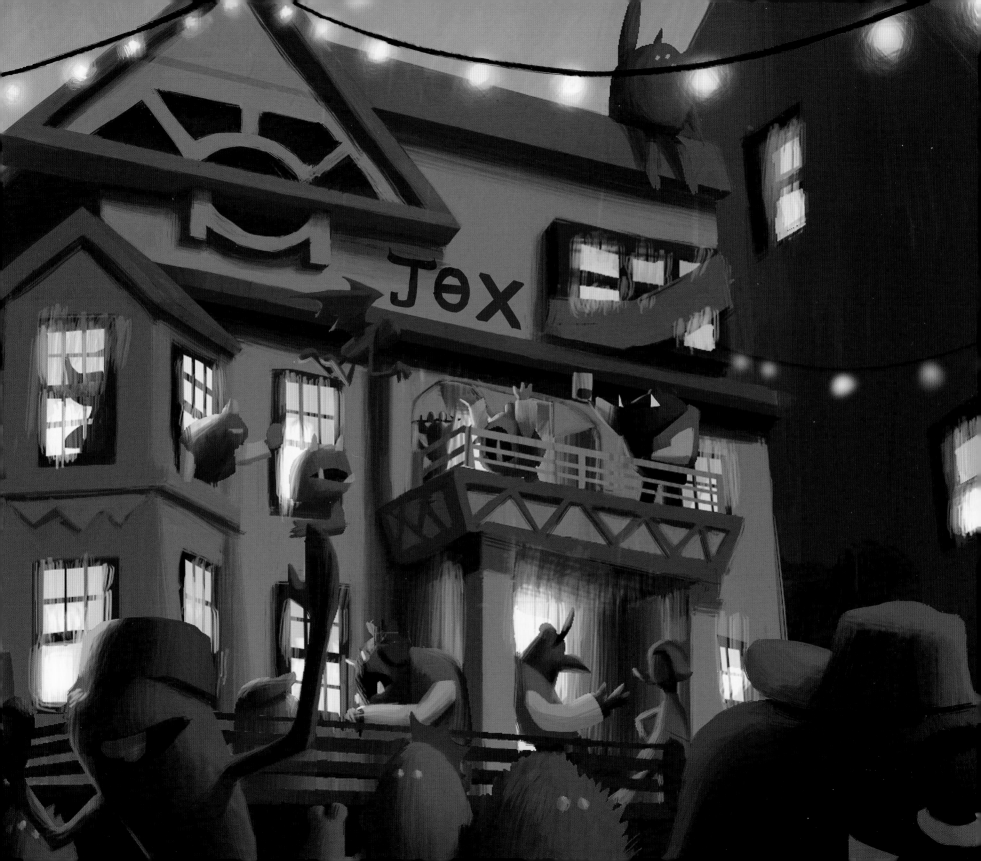

"**I**f Mike and Sulley are both at Monsters University to scare," explains writer Dan Gerson, "then getting kicked out of the Scaring Program is the strongest possible setback we can throw in their path. The question becomes: how do they get back into the Scaring Program? We realized there had to be some way outside the set curriculum, some loophole or bet that would allow them to get back in. And from that naturally came the Scare Games and rival fraternities, and [Mike and Sulley] joining a fraternity."

Dan Scanlon recalls that the idea of a fraternity full of misfits "came out of the desire to keep Mike and Sulley as underdogs—to put them in the worst possible situation. But it also came from the desire to give them someone to be a parent to. What I love most about *Monsters, Inc.* is watching those two characters interact with Boo. They're at their best when they're taking care of something, or someone. In this story, they get to do that for Oozma Kappa. They're like the arguing parents of this very eager, sincere group." Each Oozma Kappa fraternity brother was designed to resonate with a different part of Mike and Sulley's emotional arcs and reflect a different facet of the college experience.

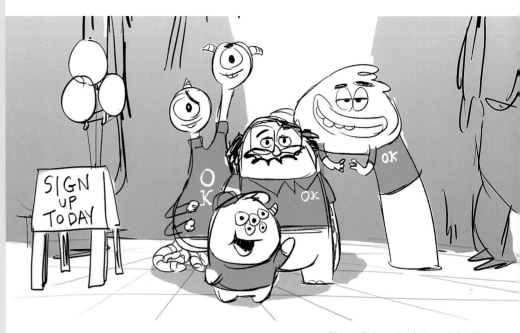

Shion Takeuchi | digital | 2011

Dan Scanlon | pencil | 2011
pages 68–69: **Jennifer Chang** | digital | 2011

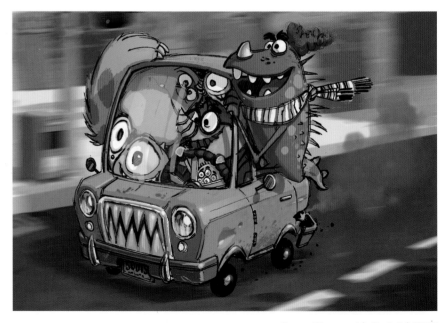

Jason Deamer | digital | 2010

OOZMA KAPPA

Creating these characters to play off of Mike and Sulley, and plug into the theme of their journey, was one of the more exciting, fun parts of the process. For whatever reason, we had a good sense of who those characters were even when they were brand-new—the misfit frat introduction has changed very little from the first time it was written. Sometimes you pull your hair out writing a sequence, and sometimes it just comes to you.
—Robert Baird, writer

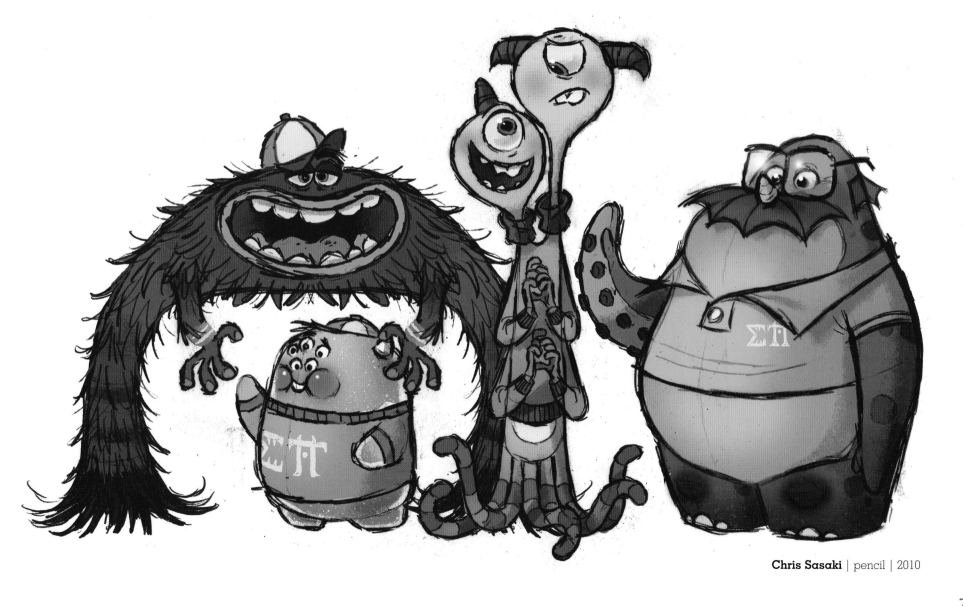

Chris Sasaki | pencil | 2010

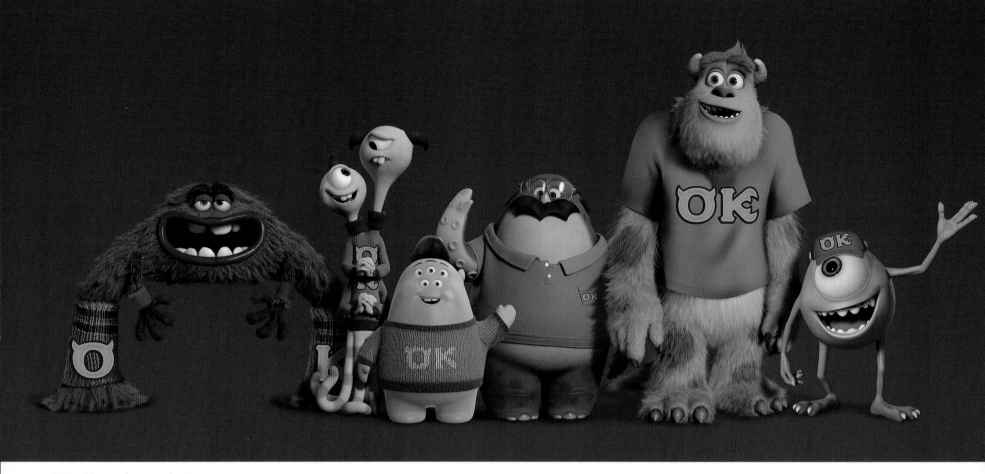

Ricky Nierva | digital | 2012

It's a sports movie, so team colors are extremely significant. The OKs are green, Mike's color, and their progress goes along with Mike's emotion. During the success montage, when Oozma Kappa start winning, we start to fill the screen with green. As they gain in popularity, fans and background monsters start wearing green T-shirts and carrying green banners. We pushed the green lights and evergreen vegetation, since the second act is in the winter time, to support OK's success in the second act. You start to feel, Mike is winning! The misfits are winning!
—Dice Tsutsumi, shading and lighting art director

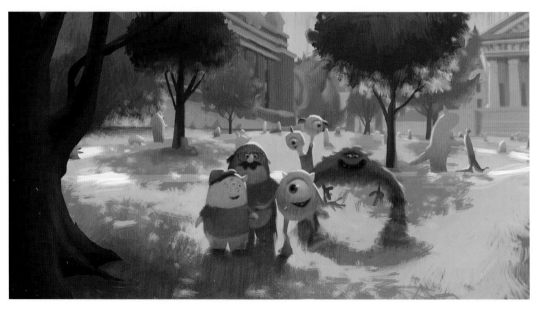

Shelly Wan | digital | 2012

Structurally, the Oozma Kappas kind of step in for Boo as the third party that eventually heals Mike and Sulley. Without the Oozma Kappas, they wouldn't have got stuck together, they wouldn't have had this whole journey together. And it's only in caring for them that both Mike and Sulley eventually come to care for themselves and each other.
—Pete Docter, executive producer

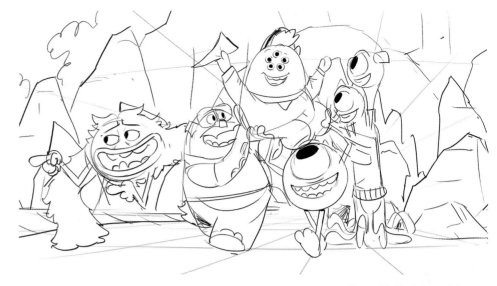

Dean Kelly | digital | 2011

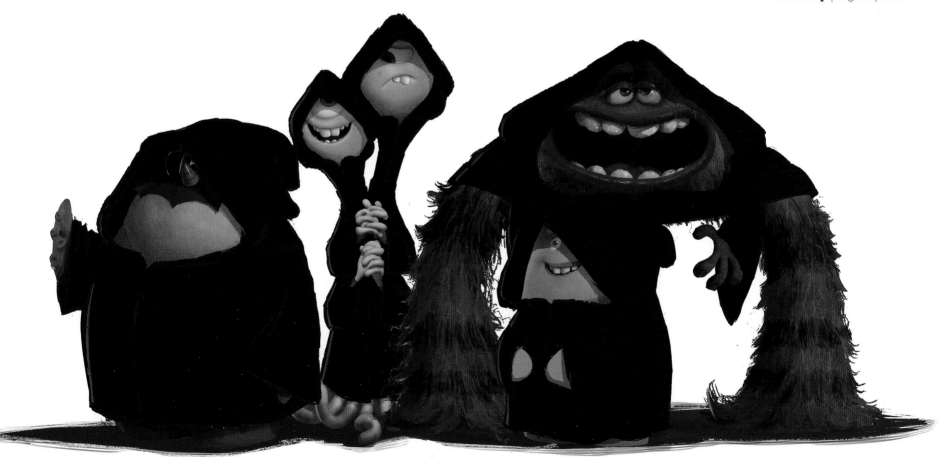

Jason Deamer | digital | 2011

SQUISHY

Going to college, some people know exactly who they are and they're very sure of themselves. Lots of us, though, have a part that is still an unmolded blob—you're not quite sure of who you are or what you're going to become. Squishy's a reflection of that. He's an amorphous blob, a piece of clay that needs to be molded.
—Kelsey Mann, head of story

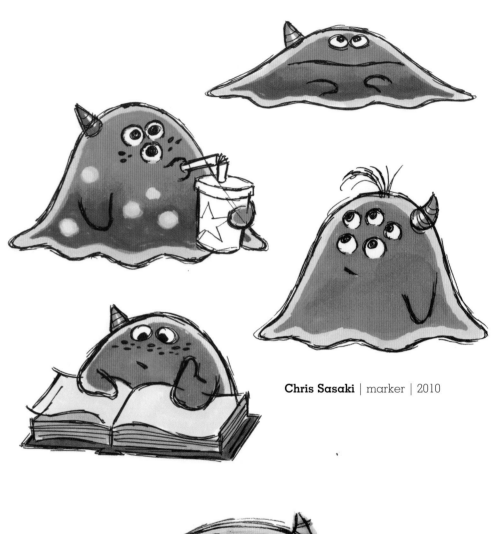

Chris Sasaki | marker | 2010

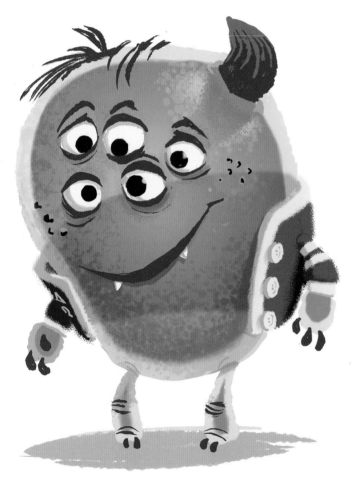

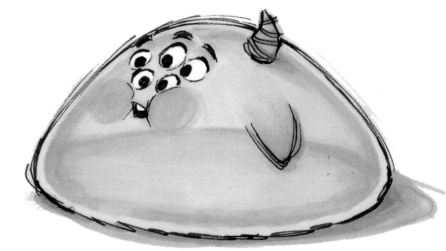

Jason Deamer | digital | 2010

Jason Deamer | marker | 2010

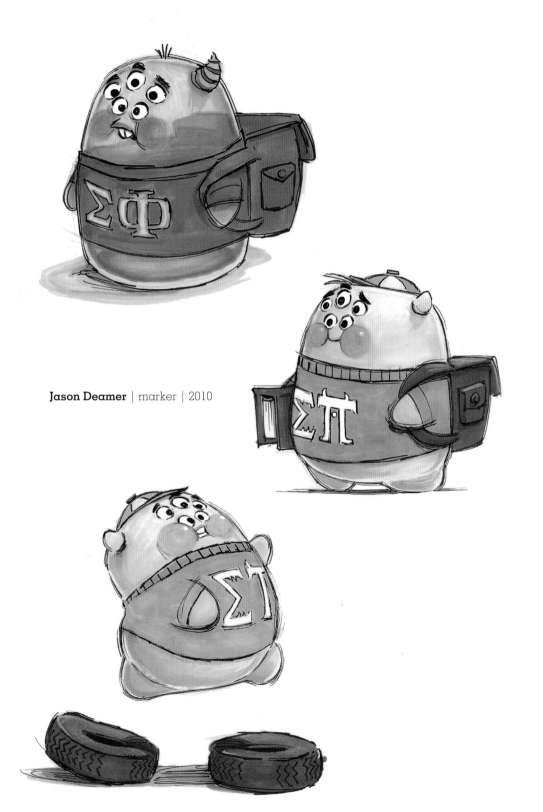

Jason Deamer | marker | 2010

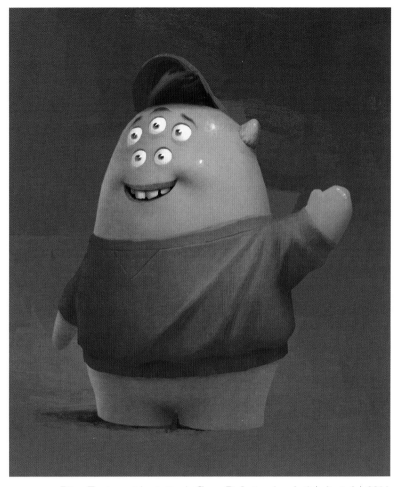

Dice Tsutsumi (painting), Greg Dykstra (sculpt) | digital | 2011

We didn't want to say Mike couldn't be a Scarer because of the way he looks, or his size. It's this other inherent thing, an intangible quality, like not being able to tell a joke. You know the joke, you're getting all the lines right, it's just that there's something not quite right in your timing. That's Mike's problem. So we needed to show that someone even cuter and littler than Mike could still be scary. And that's who Squishy is.
—Dan Scanlon, director

TERRI & TERRY

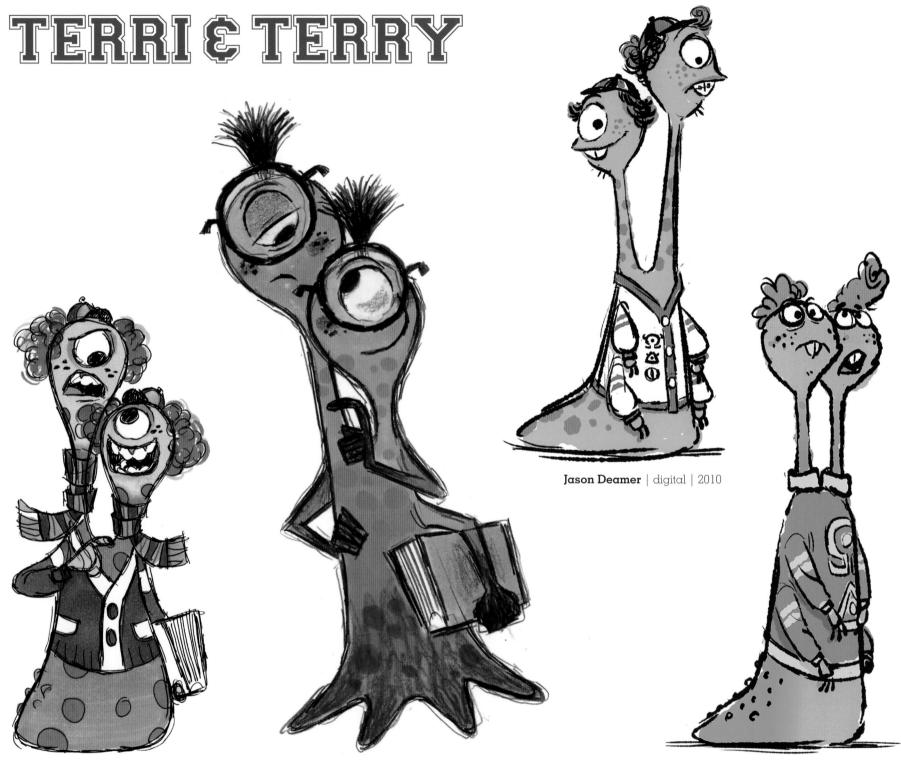

Chris Sasaki | marker | 2010

Chris Sasaki | marker | 2010

Jason Deamer | digital | 2010

Jason Deamer | digital | 2010

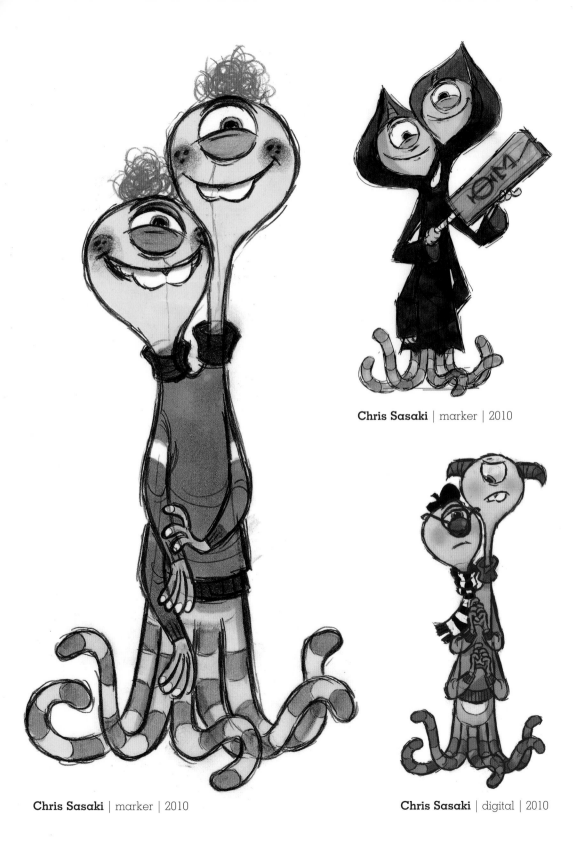

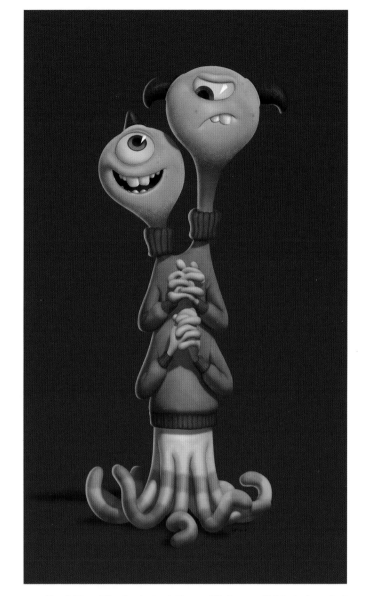

Chris Sasaki | marker | 2010

Paul Abadilla (painting), **Jason Bickerstaff** (digital sculpt)
digital | 2011

*In a way, Terri and Terry reflect Mike and Sulley.
They're two guys who just can't get along—almost a
yin and yang—despite being literally stuck together.*
—Dan Gerson, writer

Chris Sasaki | marker | 2010

Chris Sasaki | digital | 2010

DON

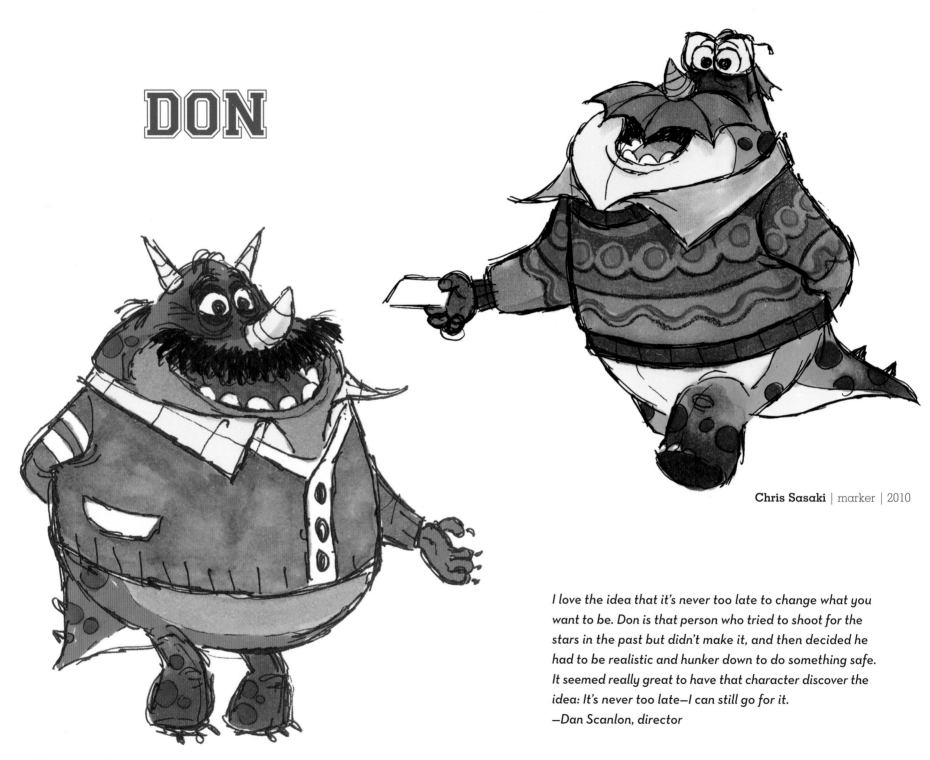

Chris Sasaki | marker | 2010

Chris Sasaki | marker | 2010

I love the idea that it's never too late to change what you want to be. Don is that person who tried to shoot for the stars in the past but didn't make it, and then decided he had to be realistic and hunker down to do something safe. It seemed really great to have that character discover the idea: It's never too late—I can still go for it.
—Dan Scanlon, director

Chris Sasaki | marker | 2010

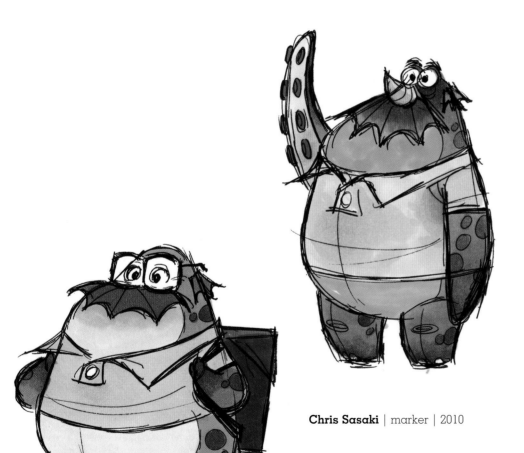

Chris Sasaki | marker | 2010

Dice Tsutsumi (painting), Greg Dykstra (sculpt) | digital | 2011

ART

Art is the burnout everyone knew in college.
—Robert Baird, writer

Chris Sasaki | digital | 2010

Ricky Nierva | marker | 2010

Art is this big bag of unanswered questions.
I always felt like the line "I can't go back to jail!"
was the one that really started him off as a
character. He's always referring to things that
you don't know anything about, and none of
the other characters know, either.
—Jeff Pidgeon, story artist

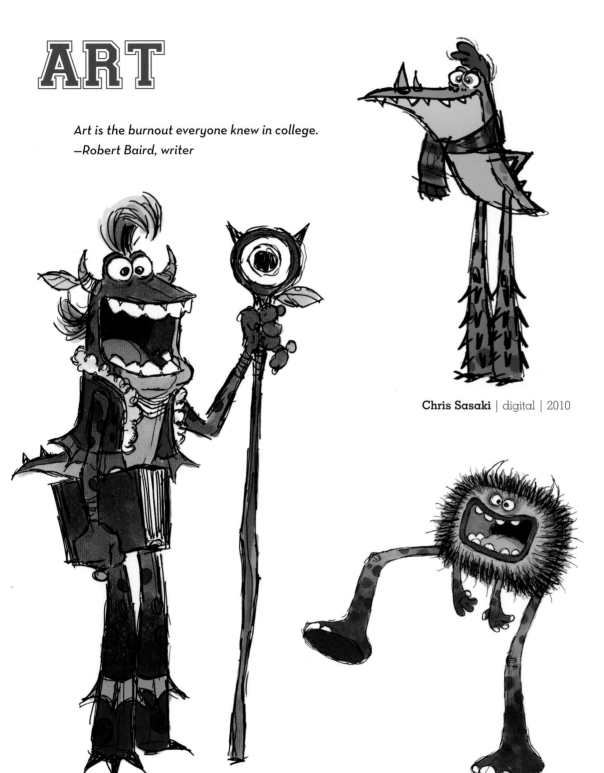

Chris Sasaki | marker | 2010

Chris Sasaki | marker | 2010

Craig Foster | digital | 2011

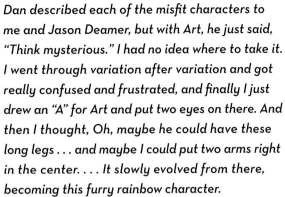

Dan described each of the misfit characters to me and Jason Deamer, but with Art, he just said, "Think mysterious." I had no idea where to take it. I went through variation after variation and got really confused and frustrated, and finally I just drew an "A" for Art and put two eyes on there. And then I thought, Oh, maybe he could have these long legs . . . and maybe I could put two arms right in the center. . . . It slowly evolved from there, becoming this furry rainbow character.
—Chris Sasaki, sketch artist

Ricky Nierva | marker | 2010

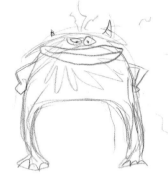

Pete Docter | pencil | 2010

Chris Sasaki | digital | 2010

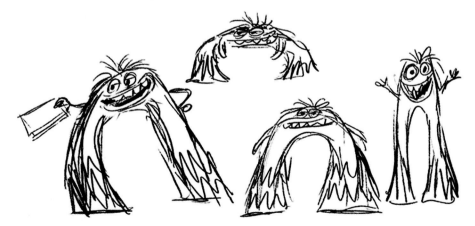

Dan Scanlon | pencil | 2011

Dice Tsutsumi (painting), **Greg Dykstra** (sculpt) | digital | 2011

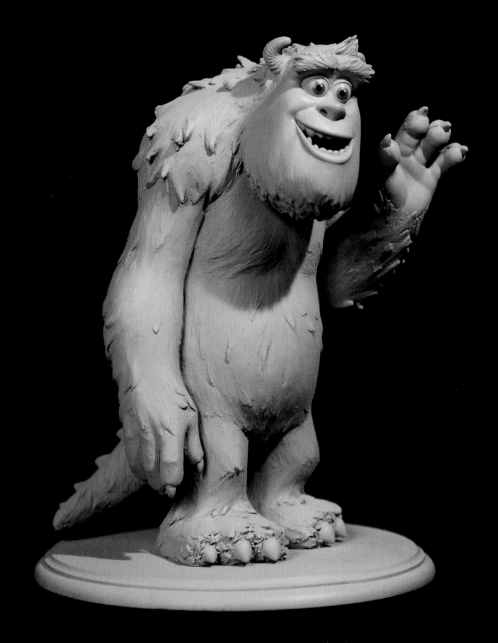

Greg Dykstra, Carol Wang | cast urethane | 2012

Greg Dykstra | cast urethane | 2011

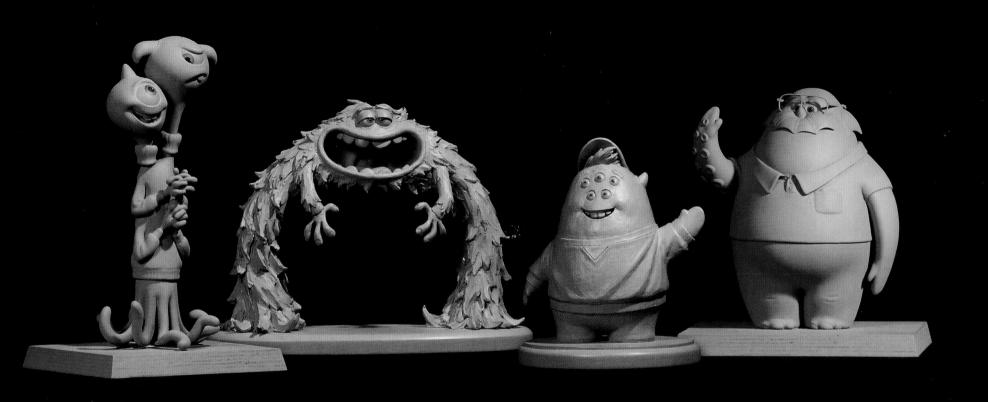

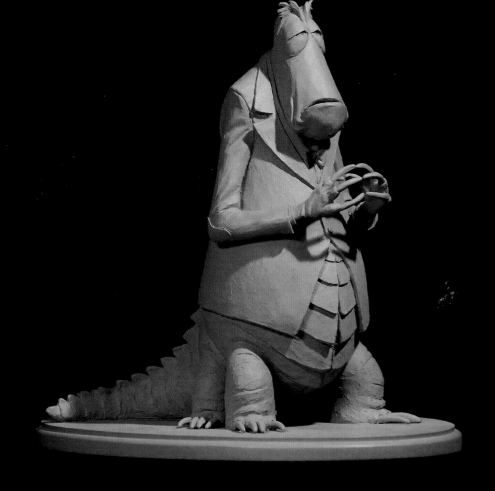

Greg Dykstra | cast urethane | 2010

Jason Bickerstaff | cast urethane | 2011

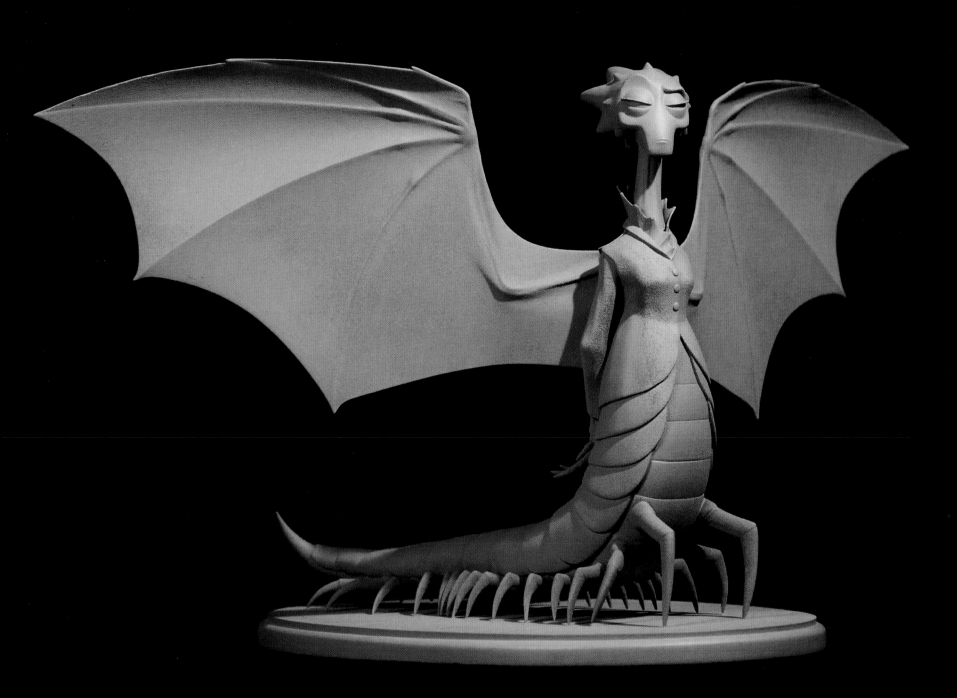

Michael Honsel | cast urethane | 2012

MS. SQUIBBLES

Jason Deamer | marker | 2011

Jason Deamer | marker | 2011

Jason Deamer | marker | 2011

Outside

Home

Jennifer Chang | digital | 2011

OK FRATERNITY HOUSE

Dice Tsutsumi | digital | 2011

Jack Chang | pencil | 2011

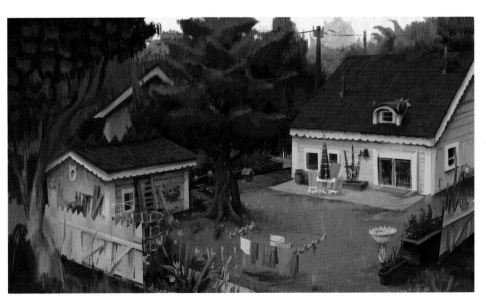

Robert Kondo | digital | 2011

Jeff Pidgeon | digital | 2010

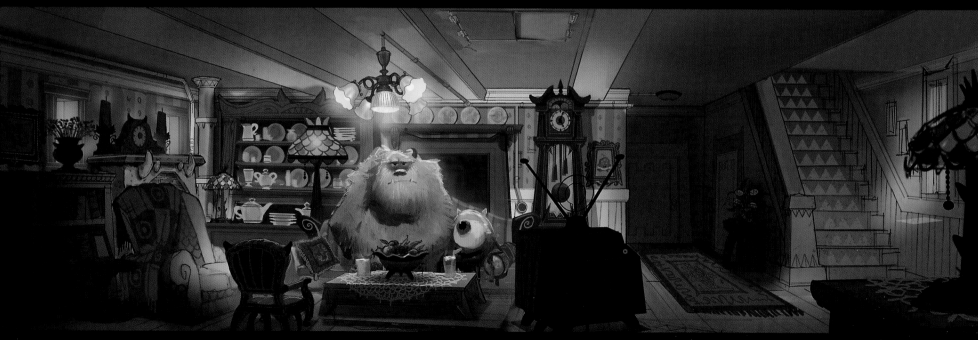

John Nevarez | digital | 2011

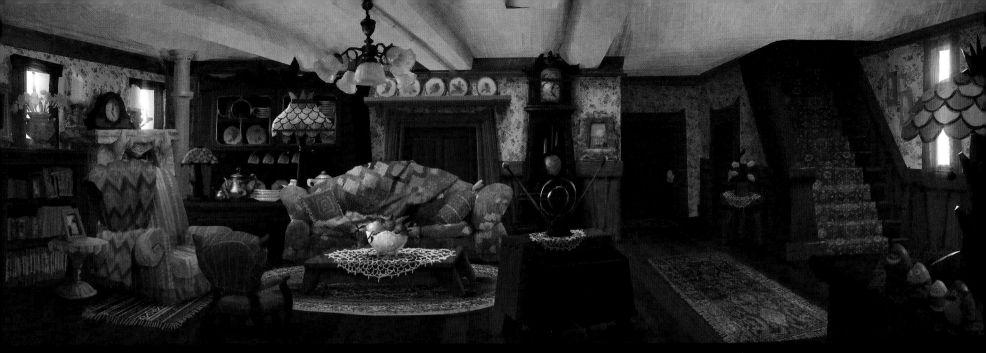

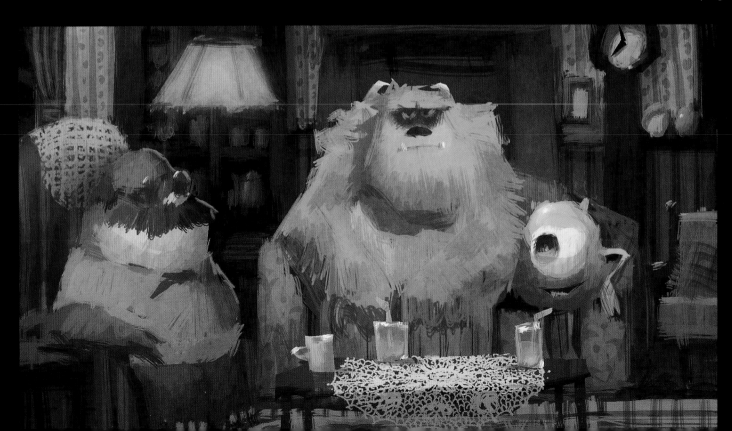

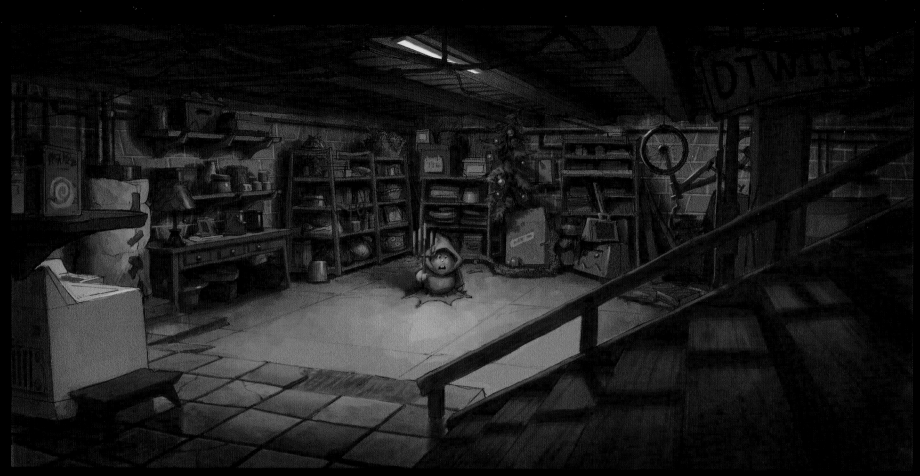

Shelly Wan | digital | 2011

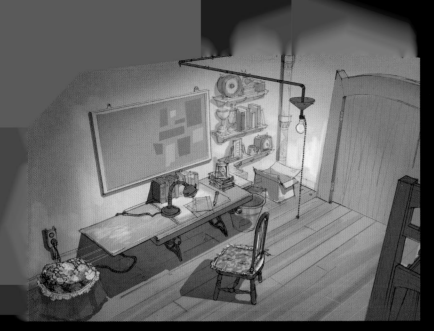

ohn Nevarez | pencil | 2011

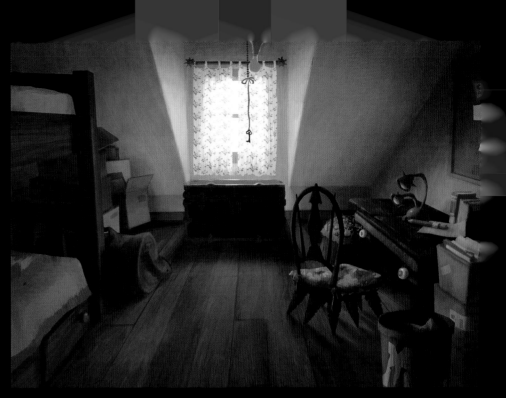

Jennifer Chang (painting), **John Nevarez** (design) | digital | 201

We wanted the Oozma Kappa house to look like a little old lady's house, because it's Squishy's mom's house. But we also wanted to make it monster-y, and I thought, Boy, those are not going to go together. I was shocked by what a great job Ricky and his team did making them go together. Those very swirly feminine shapes turned themselves into fangs and thorns really beautifully. That's one of the things I was most proud of when I saw what they did. I thought, I can't believe that works, but it really does.
—Dan Scanlon, director

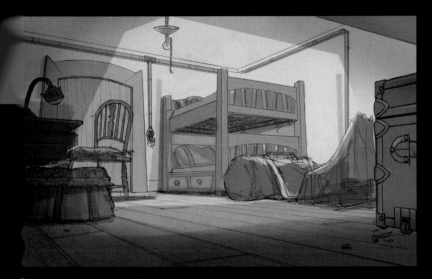

ohn Nevarez | pencil | 2011

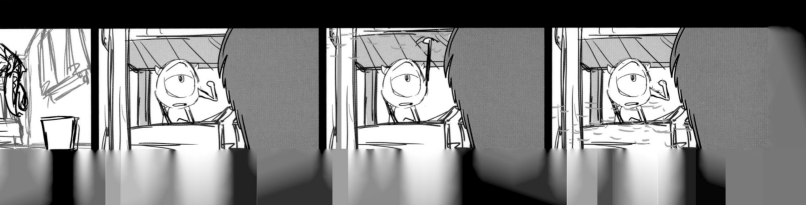

FRAT ROW

Frat Row is a very demanding set. You want it to look lived in but not completely run-down. You have a lot of interesting buildings there, but you don't want them to draw attention to themselves, because there's going to be a lot of action and you don't want the buildings to be distracting. It has to look good during the day as well as at night. So it was not easy. But the team did an amazing job. That set really shows what you get when you have a group of great people working together, all bringing their own ideas and solutions.
—Robert Kondo, sets art director

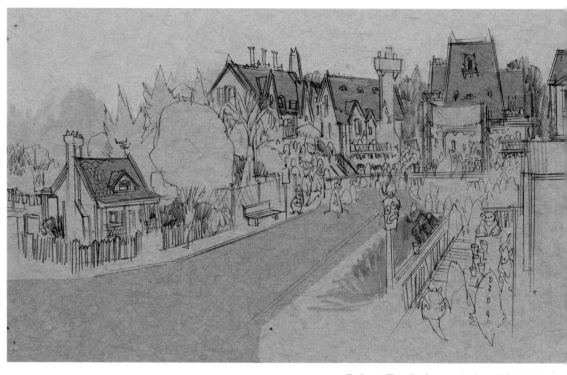

Robert Kondo | pencil, digital | 2010

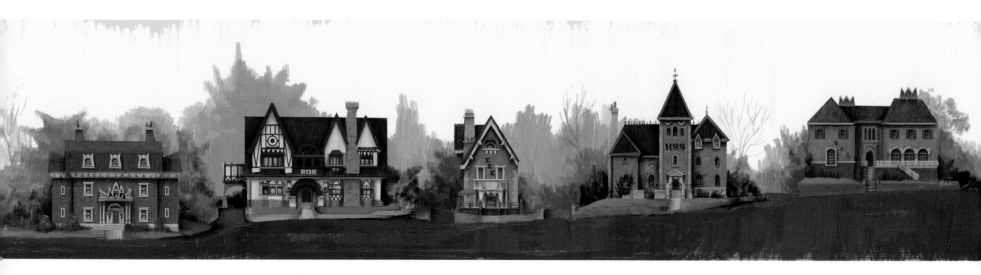

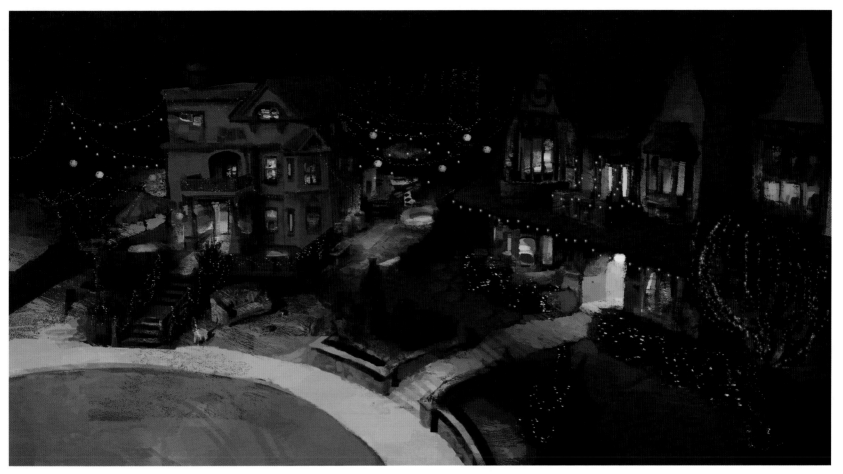

Robert Kondo (painting), **Matt Aspbury** (pre-visualization) | digital | 2012

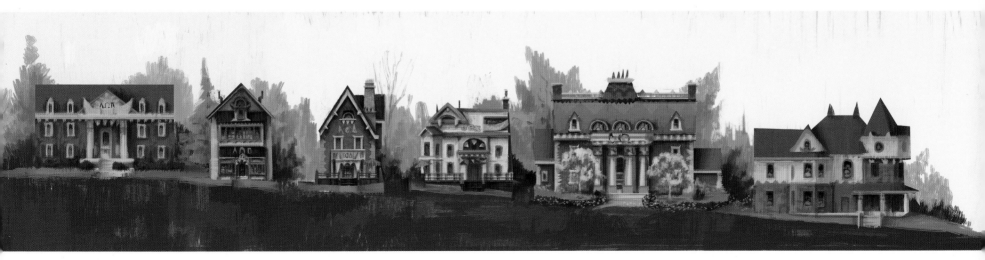

Robert Kondo (painting), **Nelson Bohol** (design), **Matt Aspbury** (pre-visualization) | digital | 2011

93

RΩR
ROAR OMEGA ROAR

The Roar Omega Roar fraternity has history. They're high-class, dignified, and very proud. Instead of a flaming, bright red, I really felt their color should be a darker crimson with gold highlights, not yellow. They don't have to ask for attention, they're already the center of attention. Compare that to the JOX fraternity, whose colors are bright yellow and orange.
—Dice Tsutsumi, shading and lighting art director

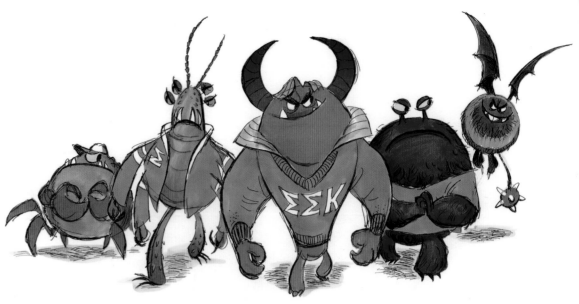

Daniela Strijleva | marker | 2010

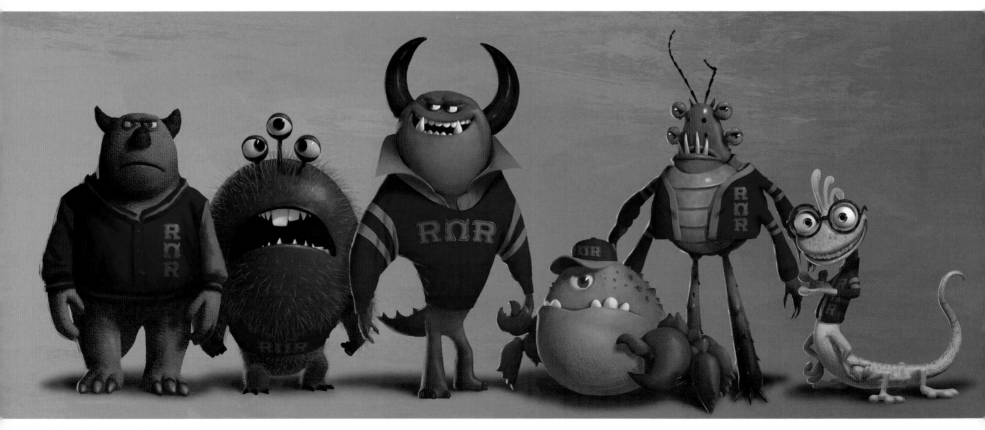

Paul Abadilla | digital | 2012

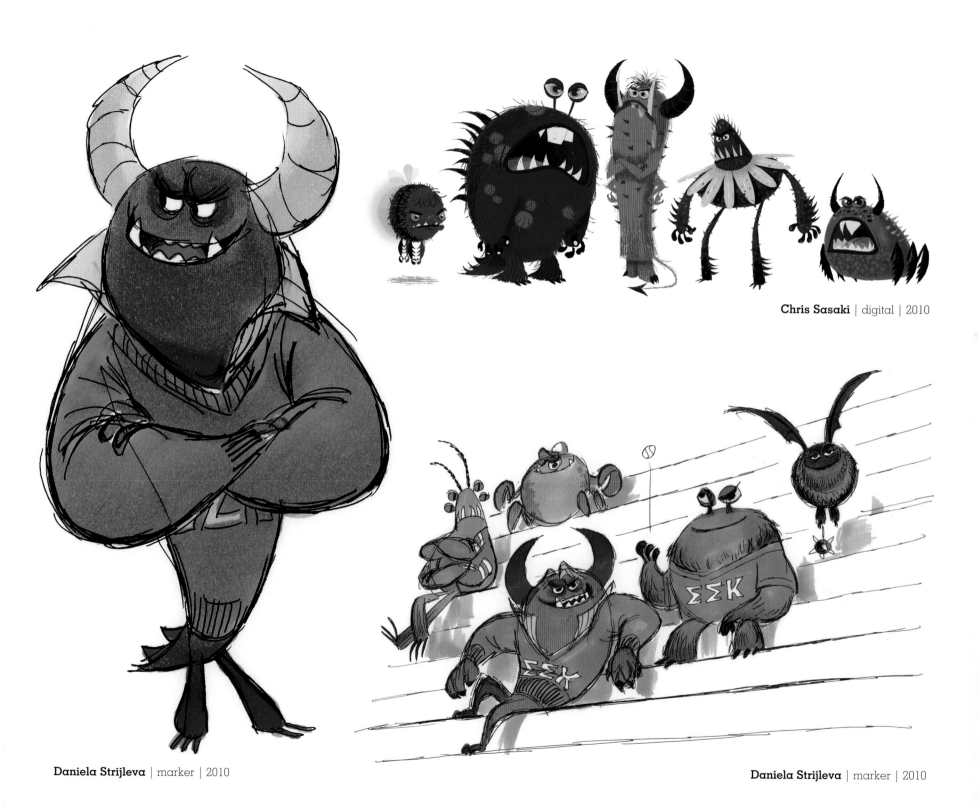

Chris Sasaki | digital | 2010

Daniela Strijleva | marker | 2010

Daniela Strijleva | marker | 2010

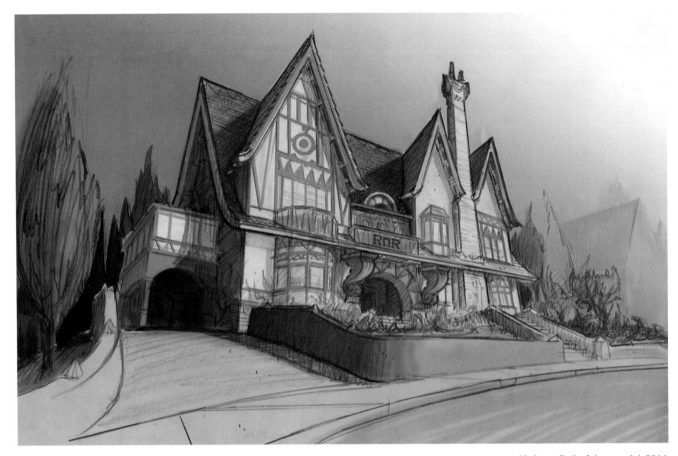

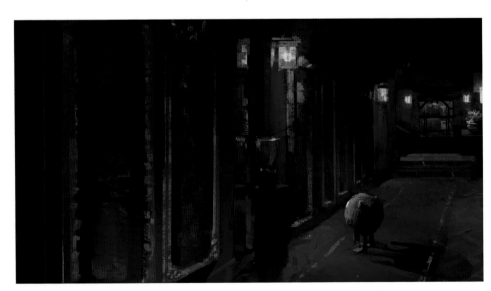

Johnny runs ROR, so if the look of the house is designed around any one character, it's him. The ROR interior gives you this feeling of tradition and entitlement, sort of "Don't touch anything." [There are] walls of trophies, walls of history, and pictures of past classes. It should give you the feeling that Johnny has something to lose, too. It's not just Mike and Sulley who have things at stake. Johnny has a tradition to live up to, and he's afraid of failing.
—Robert Kondo, sets art director

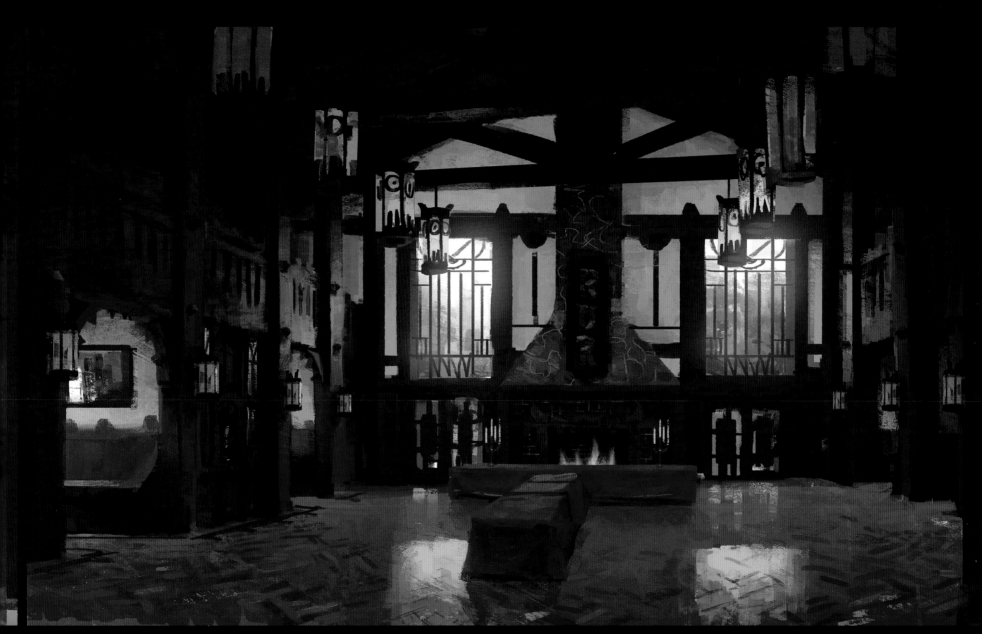

Robert Kondo (painting), **Andrew Dayton** (pre-visualization) | digital | 2012

PNK
PYTHON NU KAPPA

PNK comes off supersweet and giggly and cute, but the twist is that they're evil.
—Kelsey Mann, head of story

Jason Deamer | digital | 2011

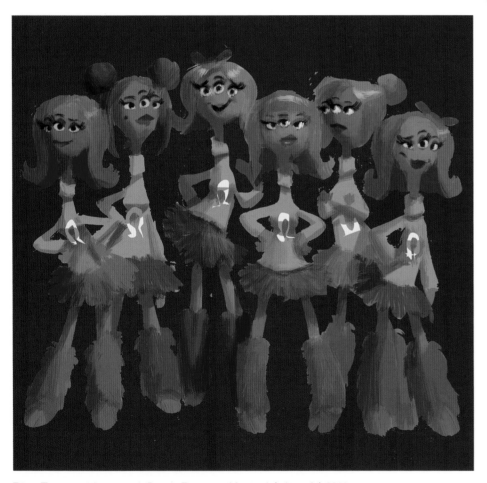

Dice Tsutsumi (painting), **Jason Deamer** (design) | digital | 2011

Nelson Bohol | pencil | 2011

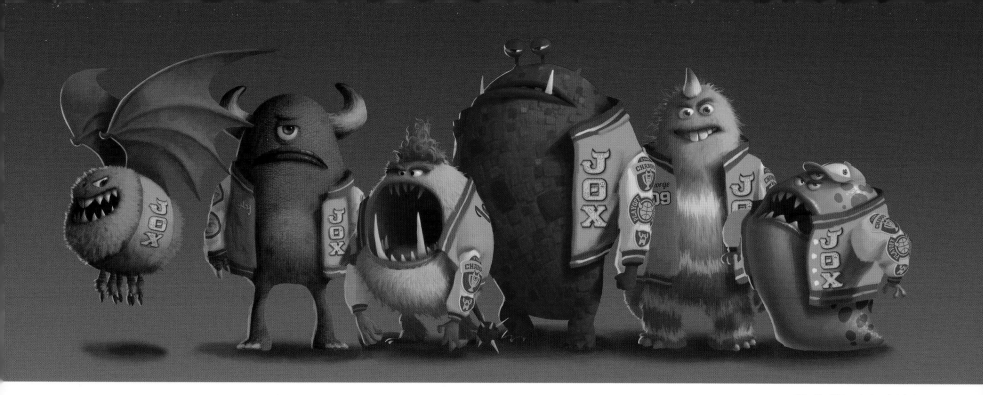

Shelly Wan | digital | 2012

JAWS THETA CHI

Cassandra Smolcic

digital | 2010

We wanted to play with the idea that it's not just about looks—just because you're big doesn't mean you're good. So JOX is one of the worst teams. They look like they'd be the best. They're huge guys with no necks and big muscles, but they're the first monsters eliminated.
—Dan Scanlon, director

Chris Sasaki | digital | 2010

Cassandra Smolcic | digital | 2010

The fun of designing the JOX house was trying to get as junky as possible without actually being disgusting.
—Robert Kondo, sets art director

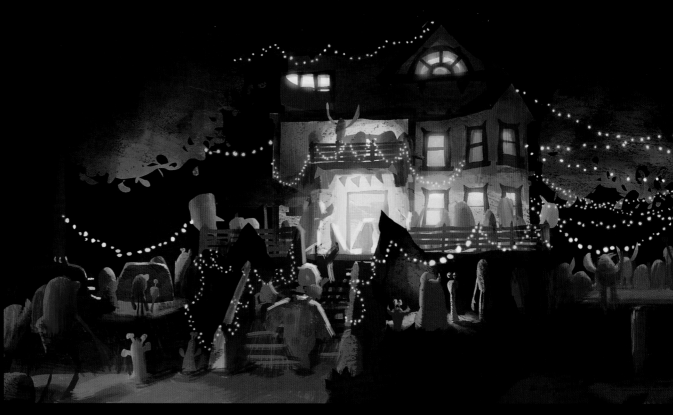

Shelly Wan | digital | 2012

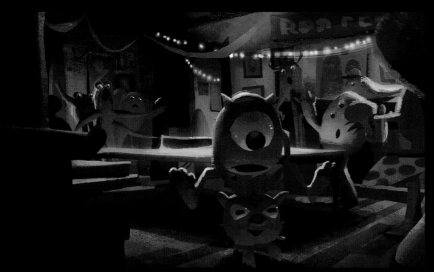

Shelly Wan | digital | 2012

Robert Kondo (painting), **Nelson Bohol** (design) | digital | 2010

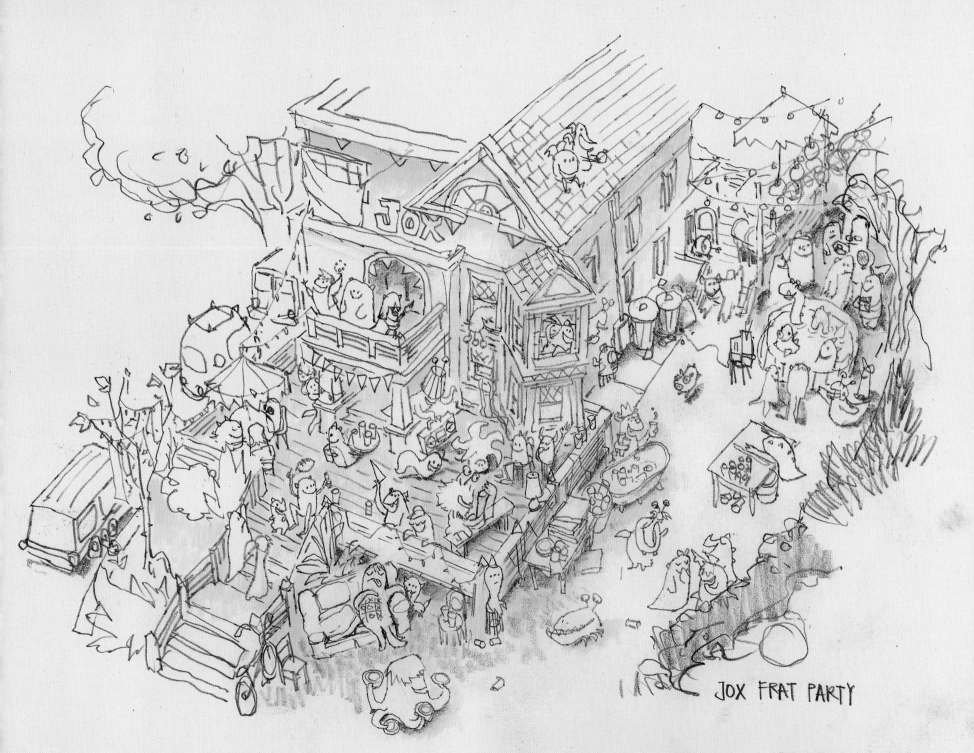

JOX FRAT PARTY

Robert Kondo | pencil | 2012

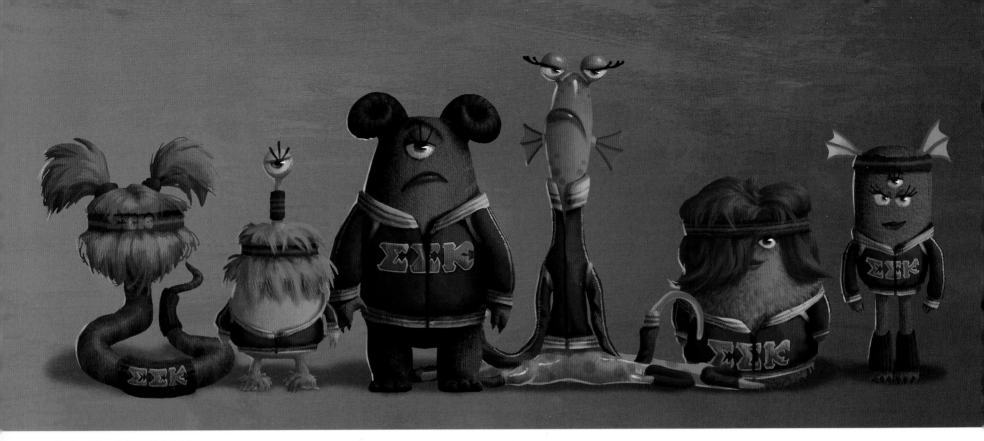

Shelly Wan | digital | 2012

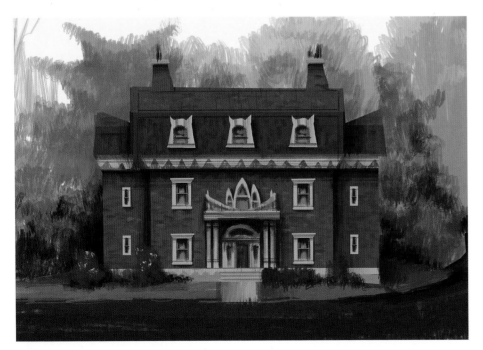

Robert Kondo | digital | 2011

ΣΣΚ
SLUGMA SLUGMA KAPPA

*EEK is more of a force to be reckoned with.
They're good—sporty and focused.*
—Dan Scanlon, director

HSS
ETA HISS HISS

We had originally thought of HSS as this mysterious secret society that you didn't know a lot about, but they won every other year, sometimes without even showing up. They eventually became a more Goth group of characters. I always felt like they were probably a bit more like the misfits, only they had already found their group and were okay with themselves.

—Dan Scanlon, director

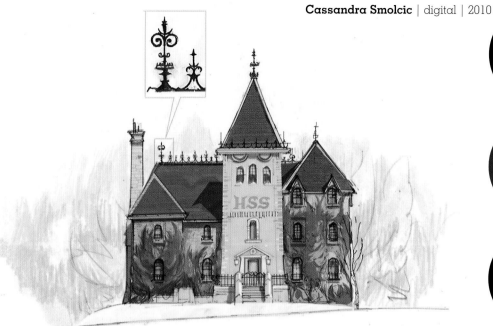

Cassandra Smolcic | digital | 2010

Nelson Bohol | pencil | 2011

Jennifer Chang (painting), Jason Deamer (character design) | digital | 2011

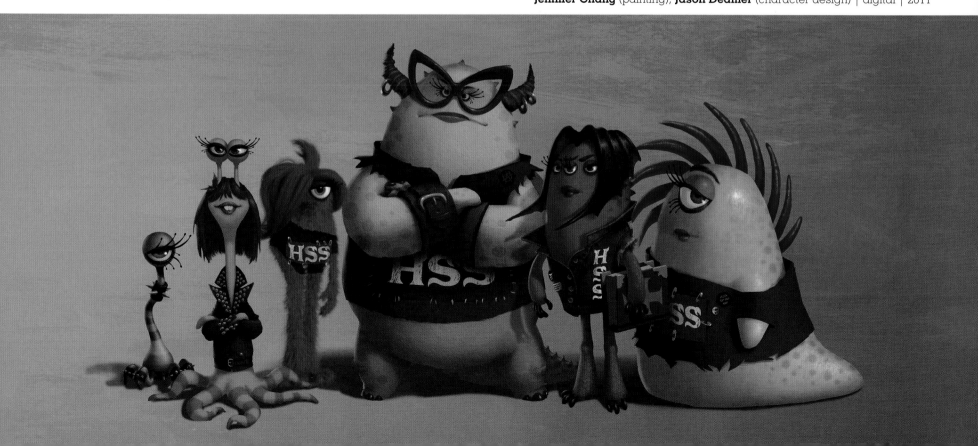

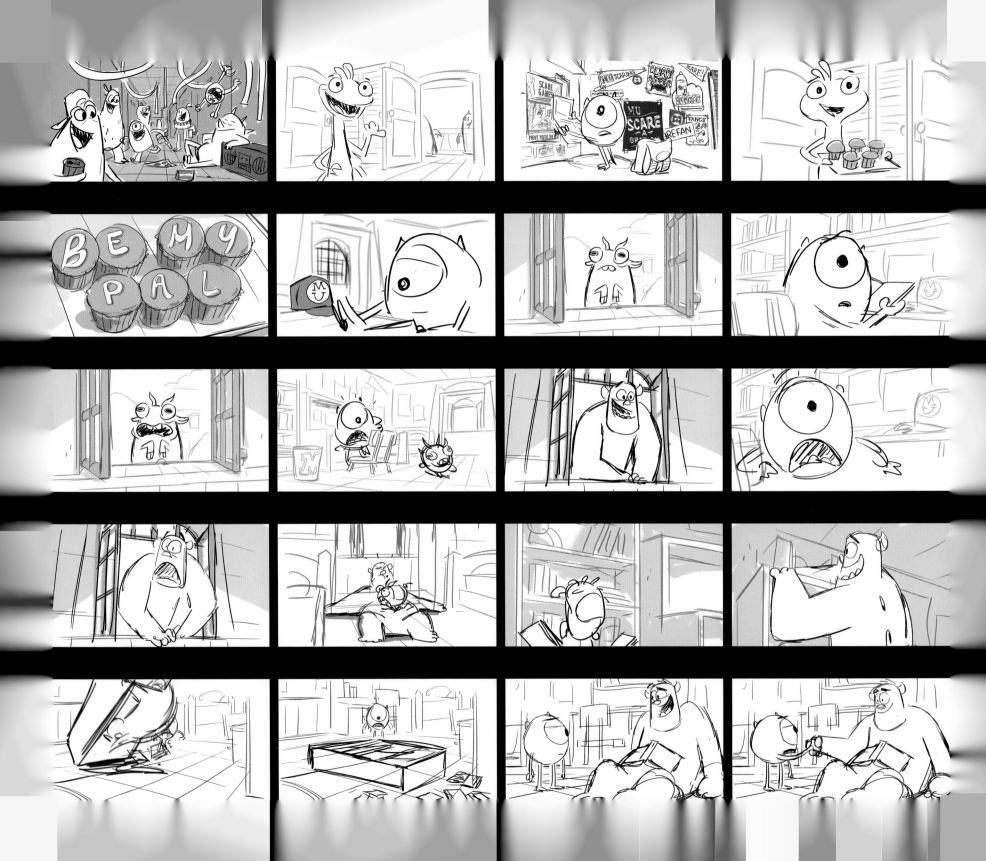

ARCHIE THE SCARE PIG

Jennifer Chang | digital | 2012

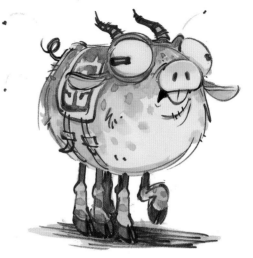

Jason Deamer | marker | 2010

I really like how Archie the Scare Pig turned out. It was challenging to figure out how to make him look like an animal and not a monster. That was a tightrope we had to walk, since a lot of our monsters are already animal-like in some way. Giving him six legs helped, and the walleyed look was key. We also gave him a square iris design, like a goat, which I think pushed it over the edge.
—Jason Deamer, characters art director

Initial concept sketch
Dan Scanlon | marker | 2008

Jason Deamer | marker | 2010

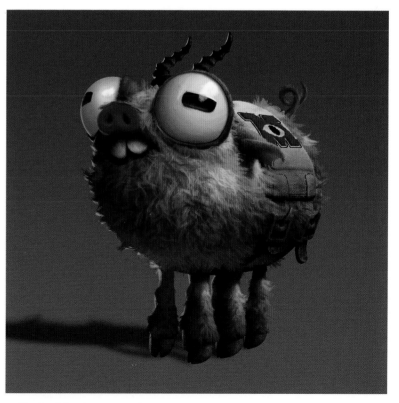

Shelly Wan (painting), **Jason Bickerstaff** (digital sculpt) | digital | 2011

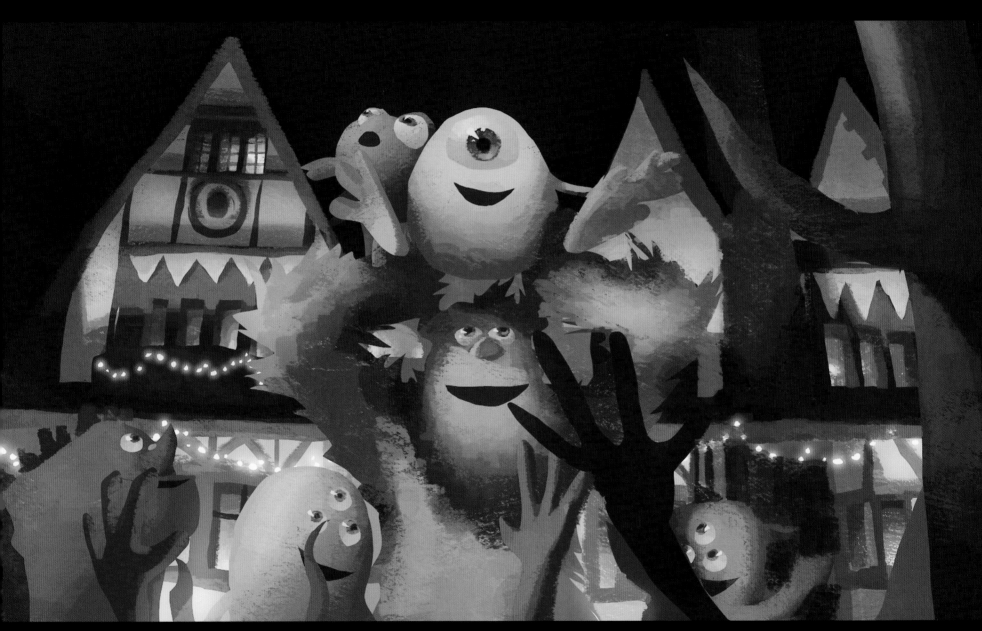

Shelly Wan | digital | 2012

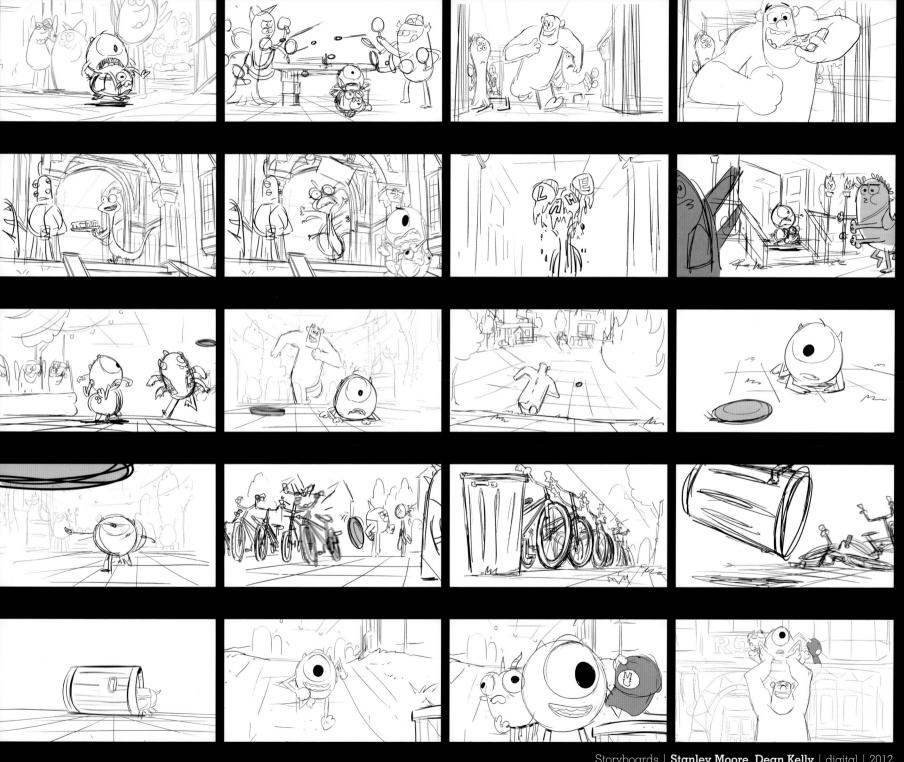

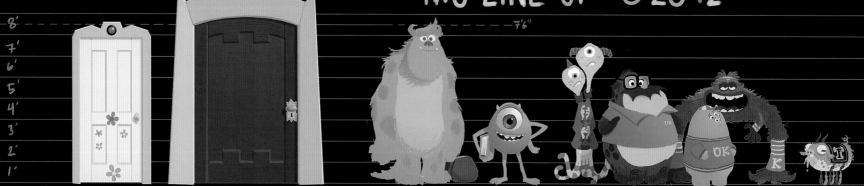

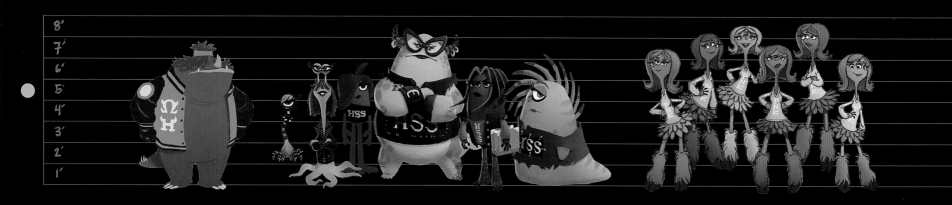

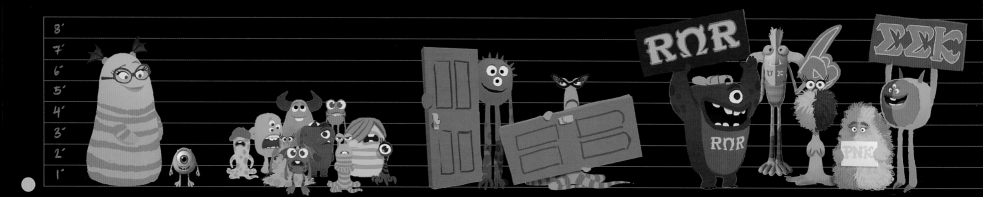

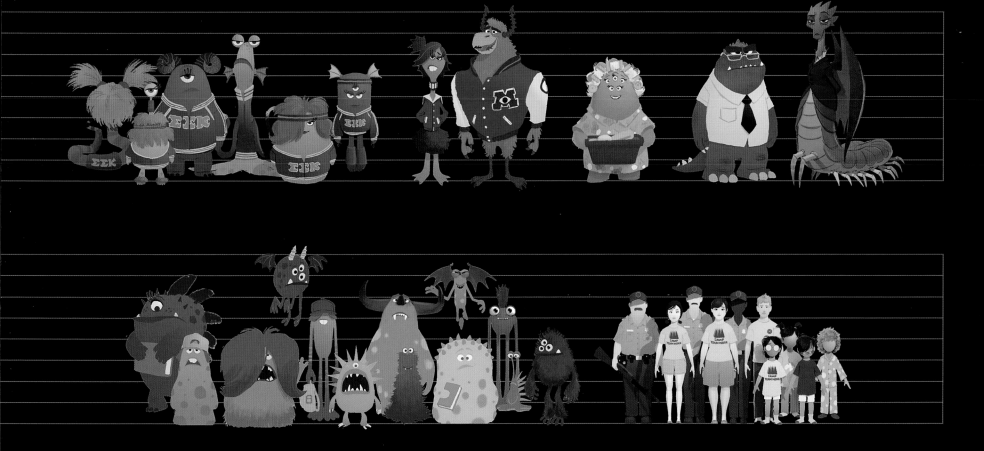

Jason Deamer | digital | 2012

THE SCARE GAMES

In need of a vivid, engaging way to show Mike and Sulley's progress toward their goal of becoming Scarers, the creative team came up with the idea of a Scare Games competition between the fraternities and sororities on campus. As Pete Docter points out, "Taking tests would be boring to watch in a movie. The Scare Games are a nice visual way to make it physical and dramatically interesting, and bring in the monster element as well."

"Compared to *Monsters, Inc.*, I think the energy of *Monsters University* is more youthful and impulsive," says editor Greg Snyder. "If *Monsters, Inc.* is all about keeping Boo a secret, keeping order, and making sure people don't find out, *Monsters University* is about being let in on the secret. We're right in the Scare Games; we're giving the audience a ticket to the underground."

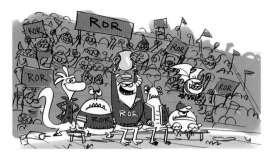

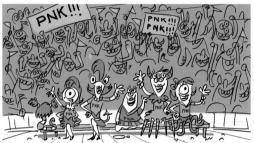

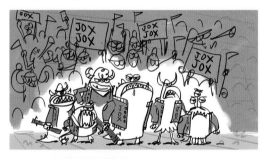

Craig Foster | digital | 2012

pages 110–111: **John Nevarez** | digital | 2012

Matthew Luhn, Bobby Rubio | digital | 2011

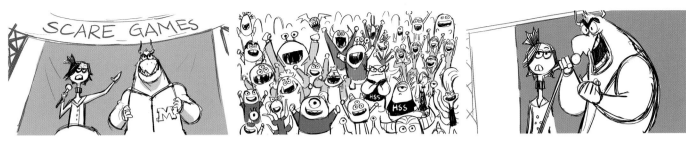

Storyboards | **Bobby Rubio** | digital | 2011

You can go the standard teenage-angst route with the acting for the Goth monsters; that's the clear place to start. But you can also make more interesting choices. For example, one of those characters, Claire, was pulled out to be [used in the film as] the president of the Greek Council. We might not have made that choice to begin with, but because we were trying to save money, we're using the character as is. So what does that mean? She's still a Goth on the surface. But she also has to be something of an achiever to be president. That complexity is where things get interesting to me.
—Scott Clark, animation supervisor

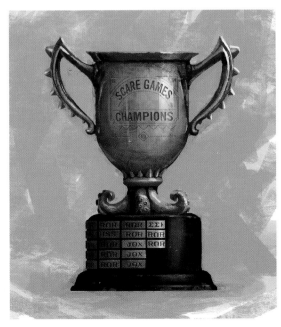

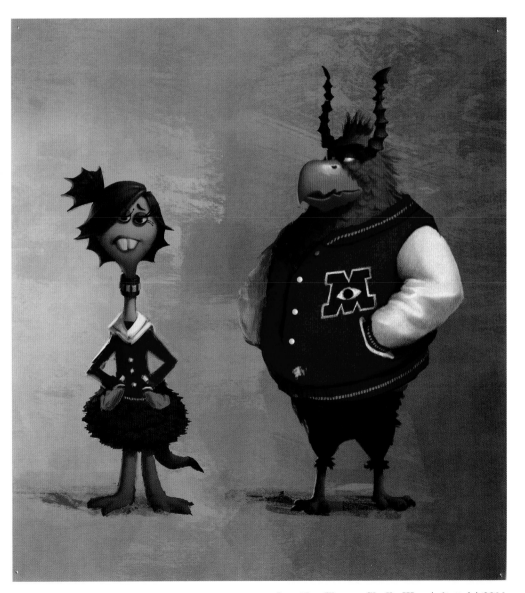

Robert Kondo | digital | 2012

Jennifer Chang, Shelly Wan | digital | 2011

For the first event in the Scare Games, when they're running through the stinging urchins, we wanted to make it feel really dangerous, like, Oh my gosh, what did I get myself into?! We wanted it to be at midnight, to have this underground feel, and Robert Kondo said, "What if it was literally underground? What if they were in the college sewer system?"
—Kelsey Mann, head of story

Dice Tsutsumi | digital | 2011

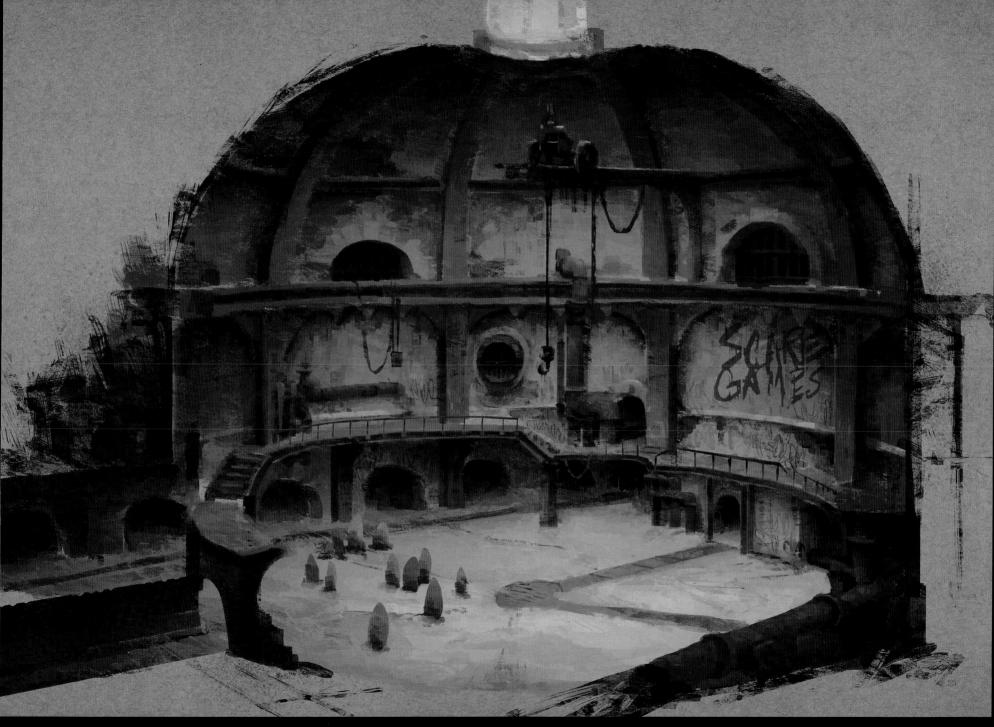

Robert Kondo (painting), **Matt Aspbury** (pre-visualization) | digital | 2012

115

Dice Tsutsumi | digital | 2012

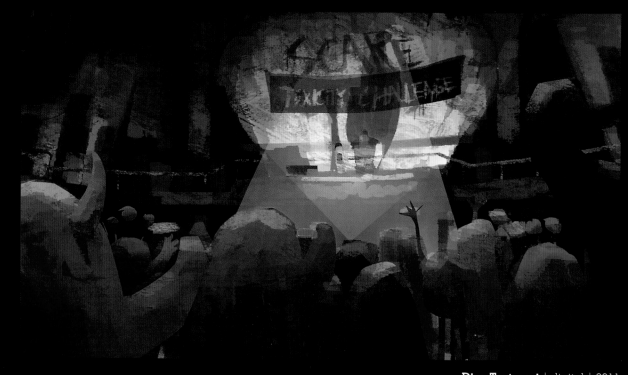

Dice Tsutsumi | digital | 2011

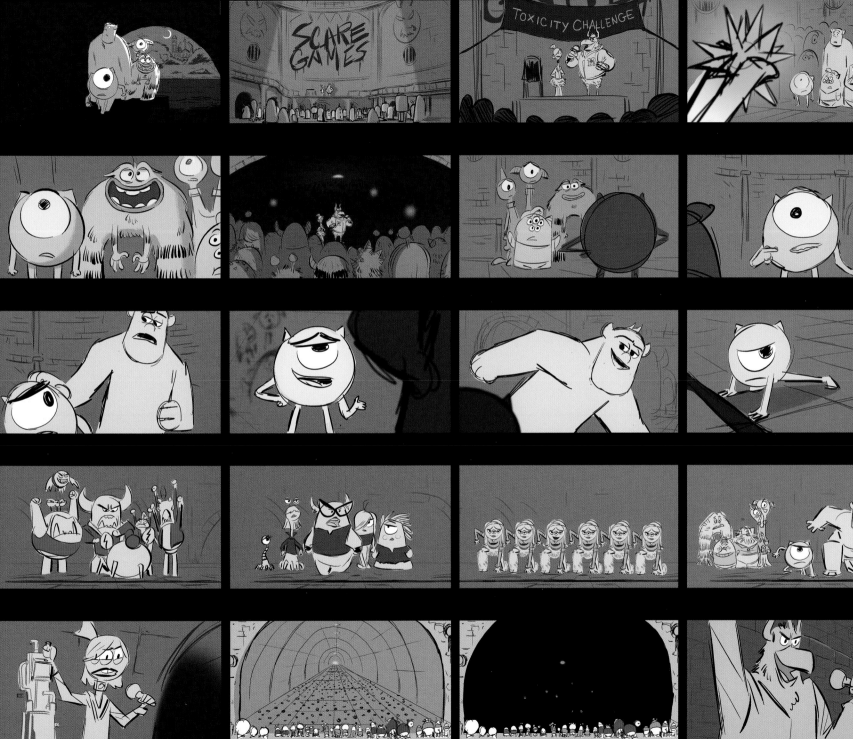

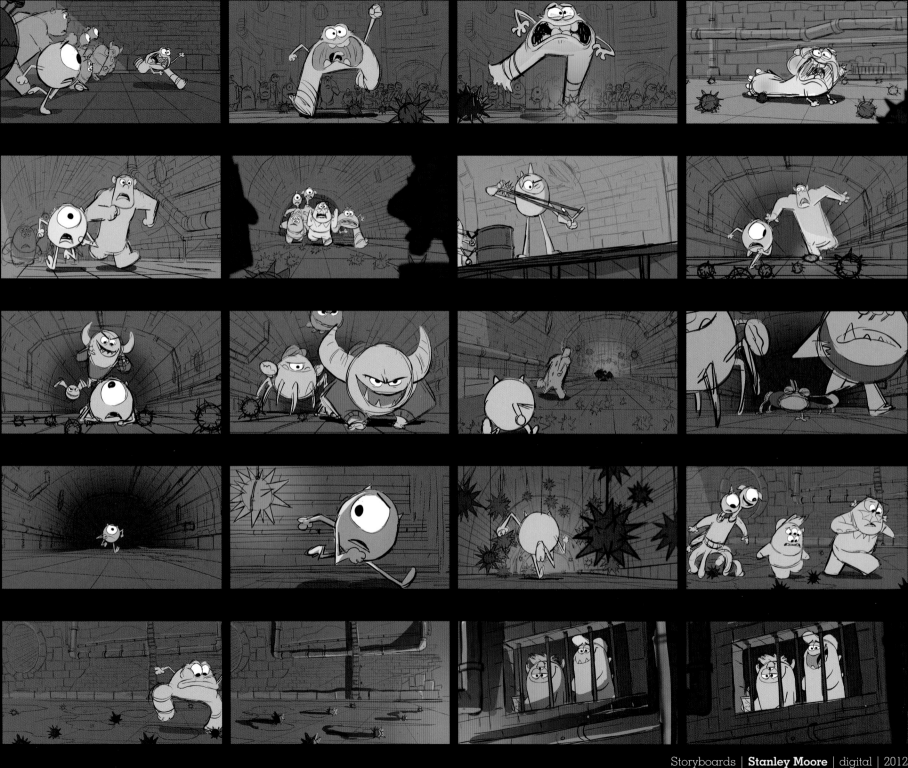

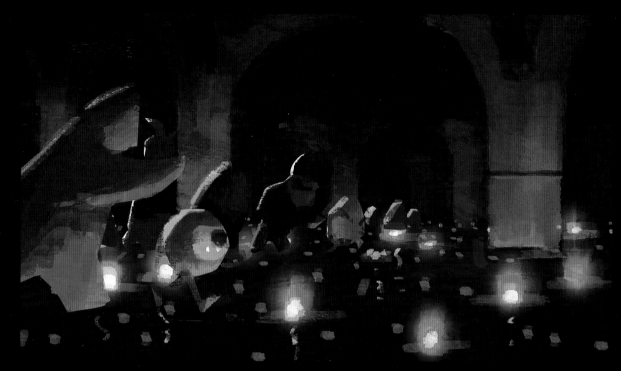

Dice Tsutsumi | digital | 2012

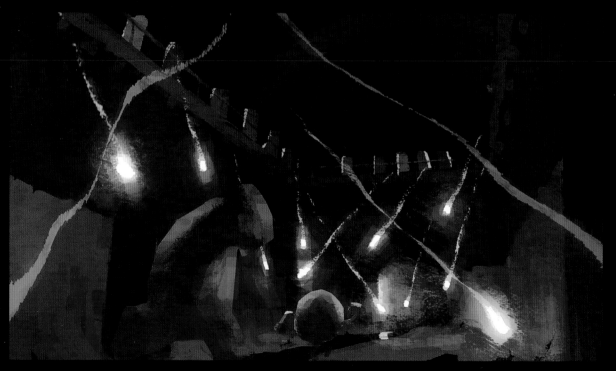

Dice Tsutsumi | digital | 2012

Pete Docter | ink | 2011

Ricky Nierva | watercolor, ink | 2011

Dice Tsutsumi (painting), **Ricky Nierva** (design) | digital | 2012

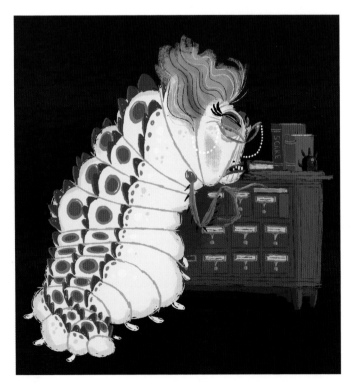

Chris Sasaki | digital | 2010

*The librarian has a very small part, but she makes
a big impact. When you first see her, she's this little
old lady librarian. But then she morphs into this
fifty-foot-high octopus-tentacled librarian who can
throw people out of the library. She's so massive,
it's almost as if the library was built around her.*
—Michael Stocker, directing animator

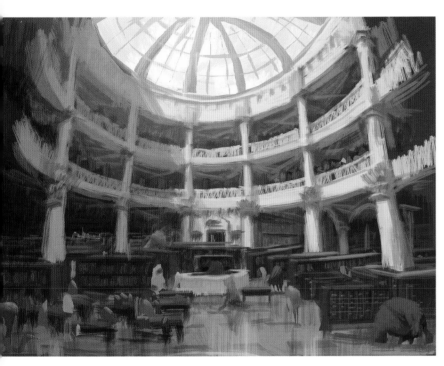

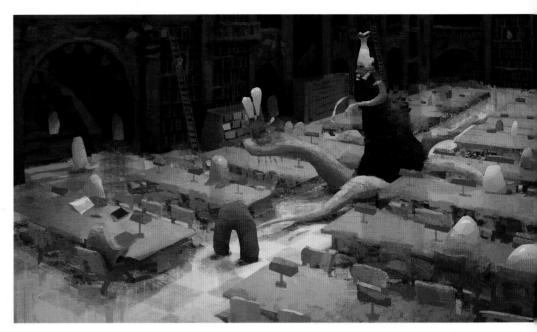

Dice Tsutsumi | digital | 2012

Robert Kondo | digital | 2010

Storyboards | **Shion Takeuchi** | digital | 2012

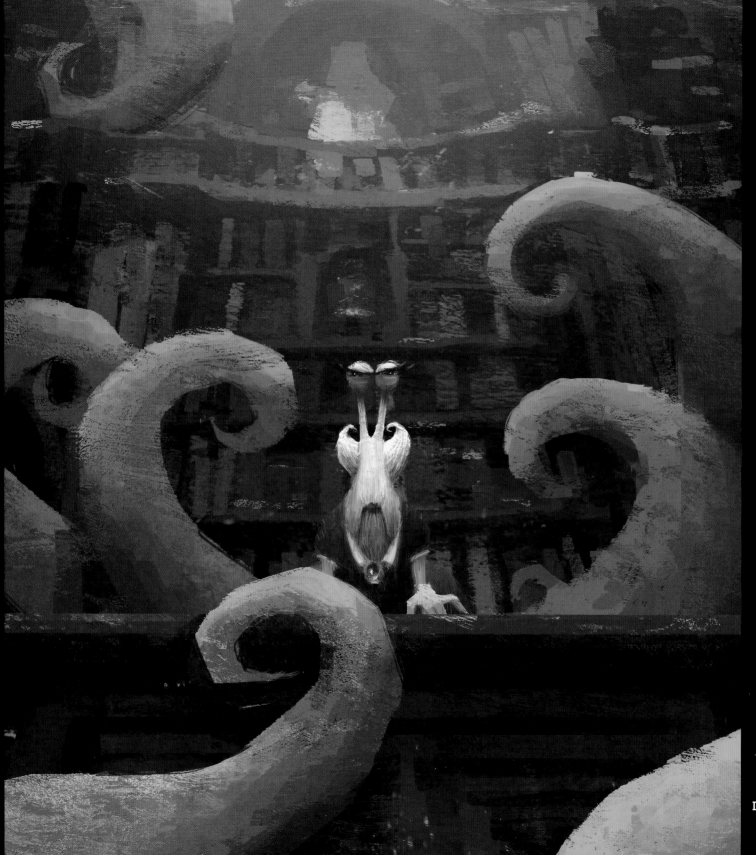

Dice Tsutsumi | digital | 2011

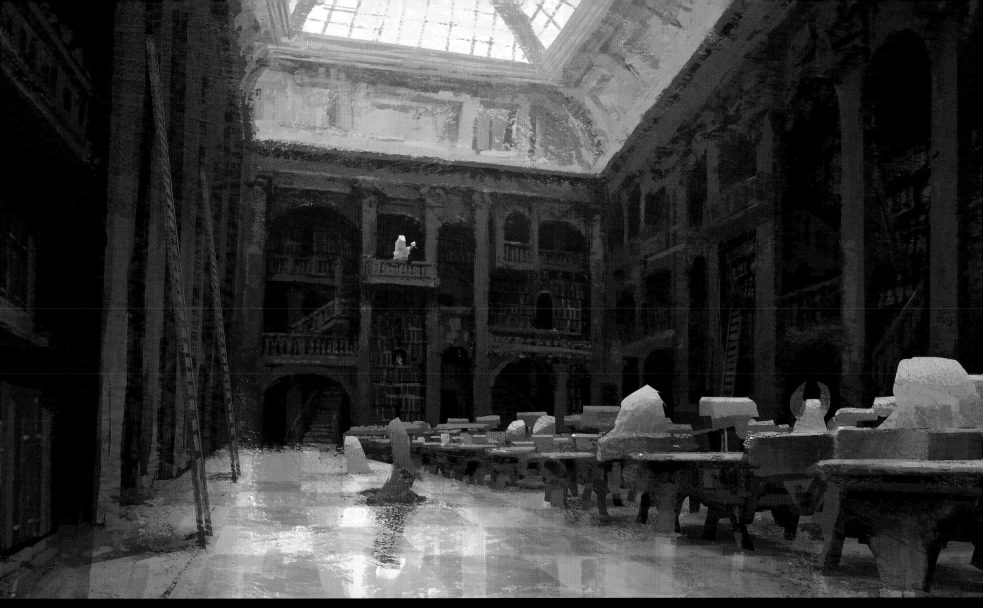

Dice Tsutsumi (painting), **Matt Aspbury** (pre-visualization) | digital | 2012

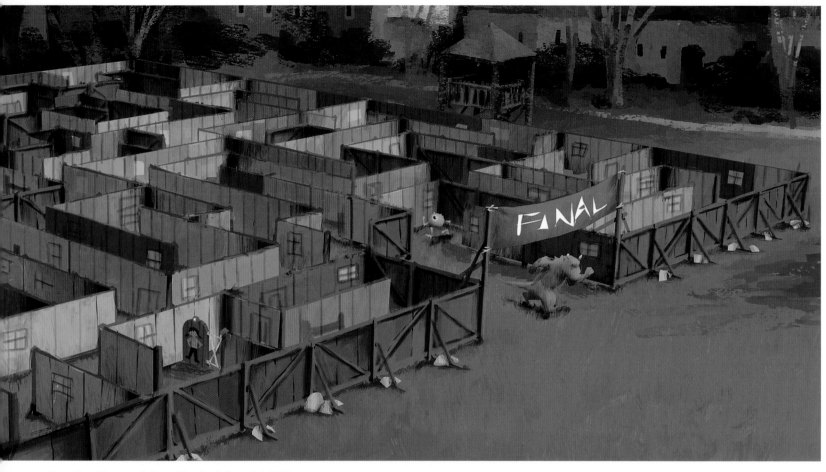

Jennifer Chang, Robert Kondo | digital | 2012

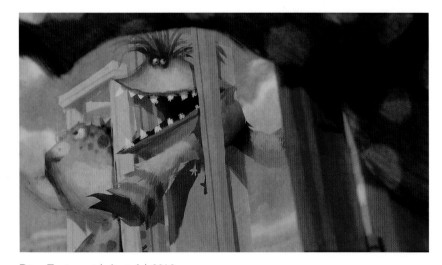

Dice Tsutsumi | digital | 2010

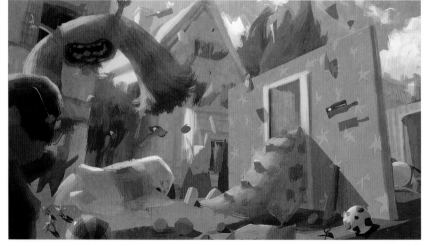

Dice Tsutsumi | digital | 2011

Dice Tsutsumi | digital | 2012

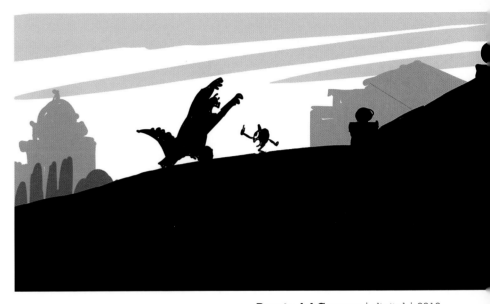

Ronnie del Carmen | digital | 2010

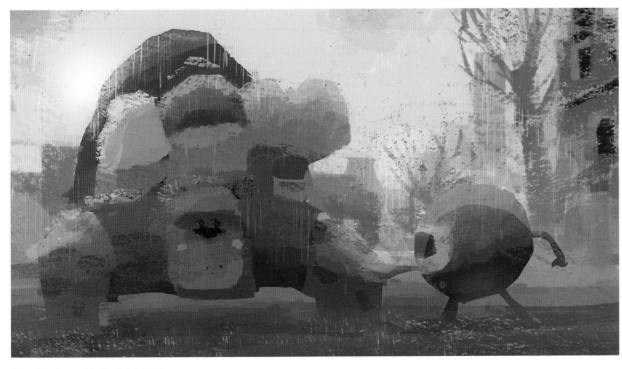

Dice Tsutsumi | digital | 2012

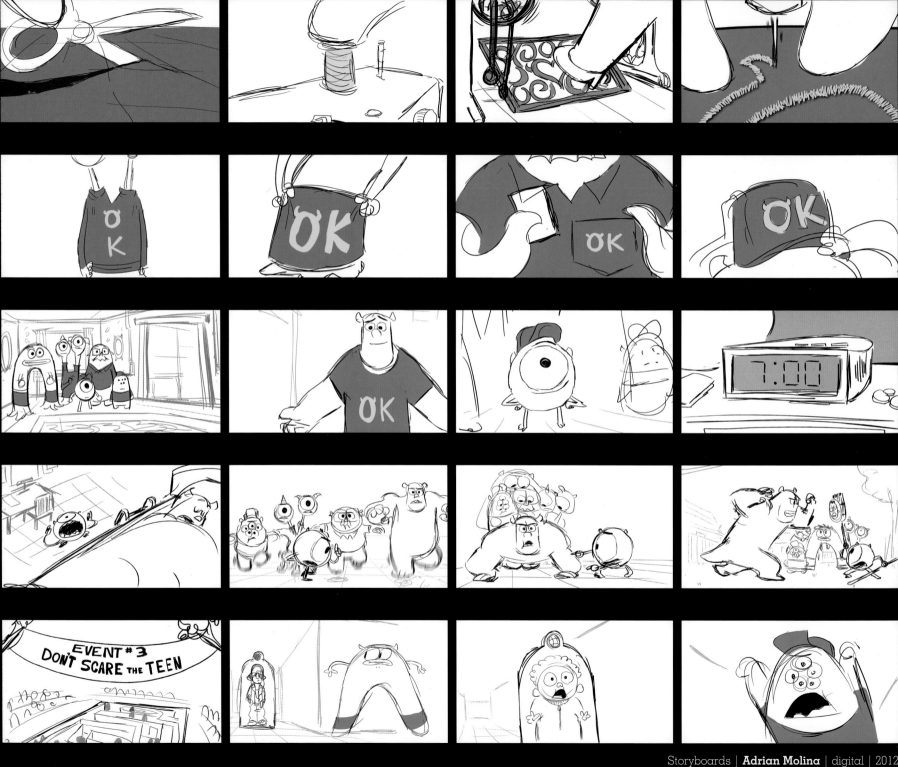

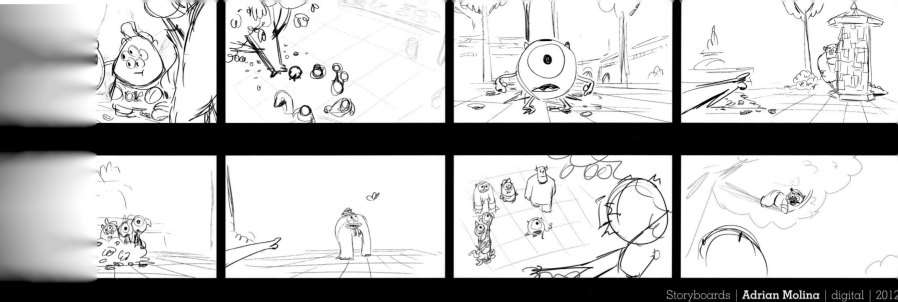

Storyboards | **Adrian Molina** | digital | 2012

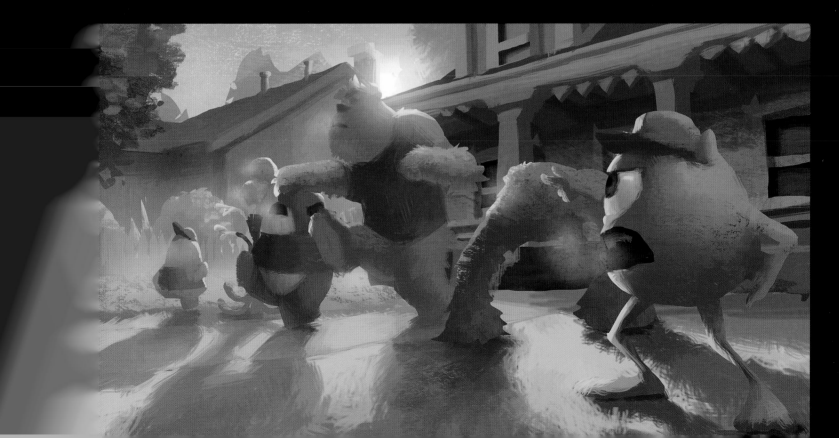

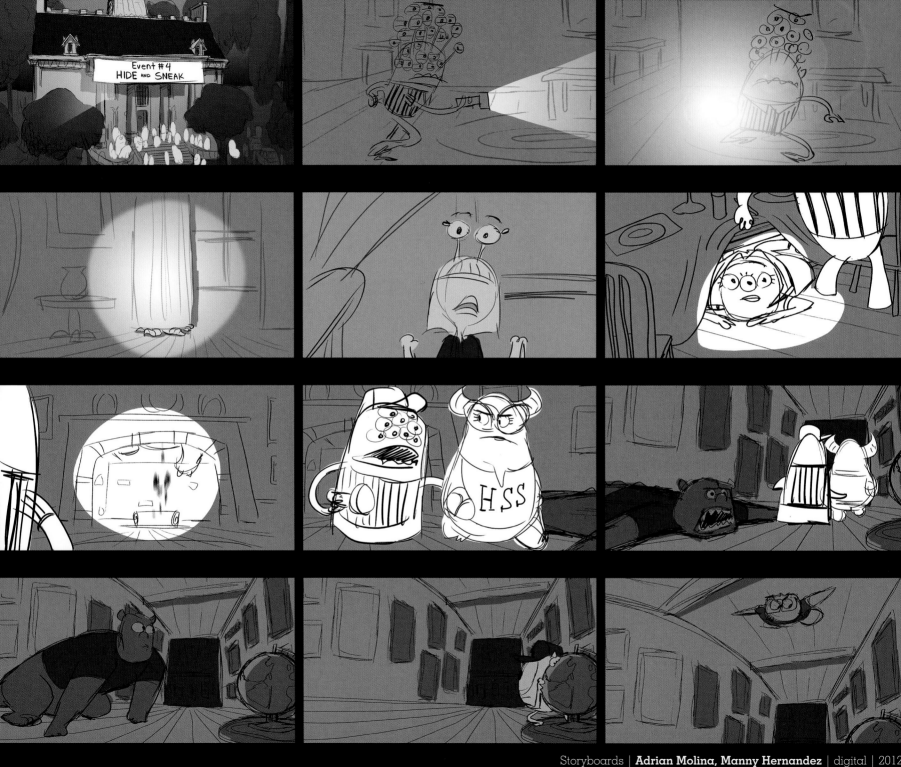

Kelsey Mann | marker | 2012

CURTAINS

BEHIND CUPS TOWER

Kelsey Mann | marker | 2012

We did a lot of exploration to figure out the fun ways different monsters could camouflage themselves in a kid's room. Sulley was particularly tricky, he's just so big and bright, how do you hide a guy like that? All you can do is start laying out ideas, good ones, bad ones, impossibly silly ones. Eventually you find a solution that makes you laugh and think, Of course this is how he would do it!
—Adrian Molina, story artist

FRAME

Kelsey Mann | marker | 2012

Behind a Mirror

Adrian Molina | pencil | 2012

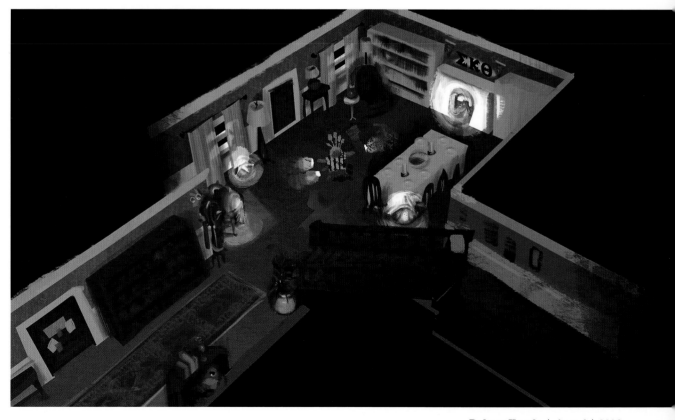

Robert Kondo | digital | 2012

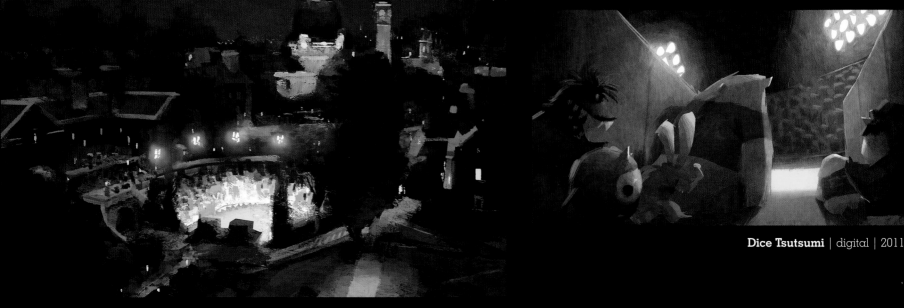

Dice Tsutsumi | digital | 2011

Robert Kondo (painting), **Matt Aspbury** (pre-visualization) | digital | 2012

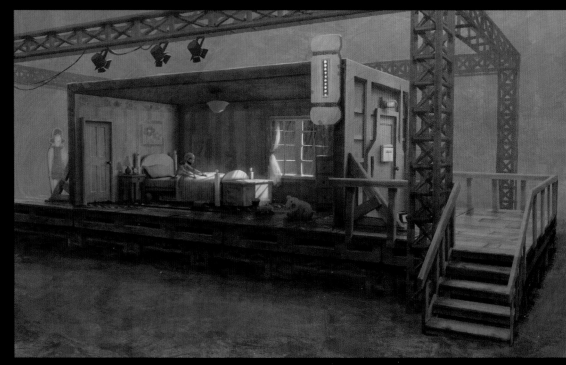

In Monsters, Inc. Randall has a real problem with Sulley and being second-best to Sulley. So we thought, Let's see that happen for the first time in this movie, in a big public event. That's why we have Sulley and Randy go head-to-head in the final competition.
—Kelsey Mann, head of story

Shelly Wan | digital | 2011

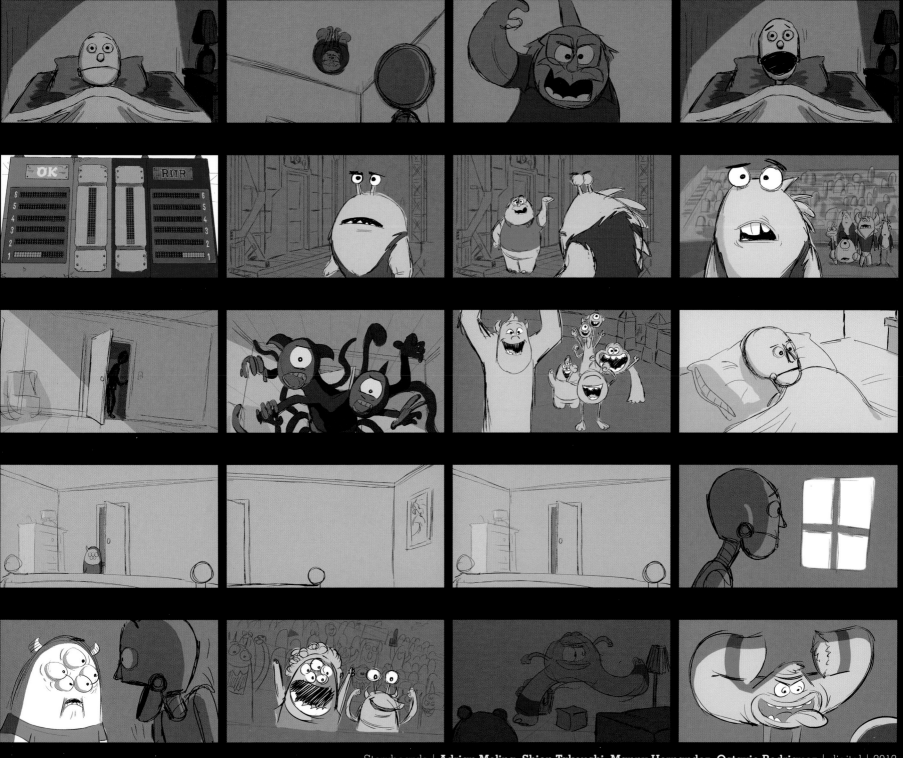

Storyboards | **Adrian Molina, Shion Takeuchi, Manny Hernandez, Octavio Rodriguez** | digital | 2012

COLORSCRIPT

As the movie was finding its structure, Dice was already meeting with lighting supervisor Jean-Claude [Kalache], production designer Ricky [Nierva], and me to talk about how we would use light and color to support the story. The idea of light versus shadow emerged from these talks. For example, Mike steps out of shadow and into light as he makes the choice to proudly cross the threshold to Monster's University; Mike and Sulley are separated by light and shadow as their budding friendship begins to fracture near the end of the film, and so on. These ideas can get lost in the process of making the movie, but luckily Matt Aspbury and his layout team, as well as Jean-Claude and his lighting team worked very closely with Dice to make sure that these concepts wouldn't get overlooked. They're not something you'll likely notice in a first viewing, but they're something you'll feel emotionally.
—Dan Scanlon, director

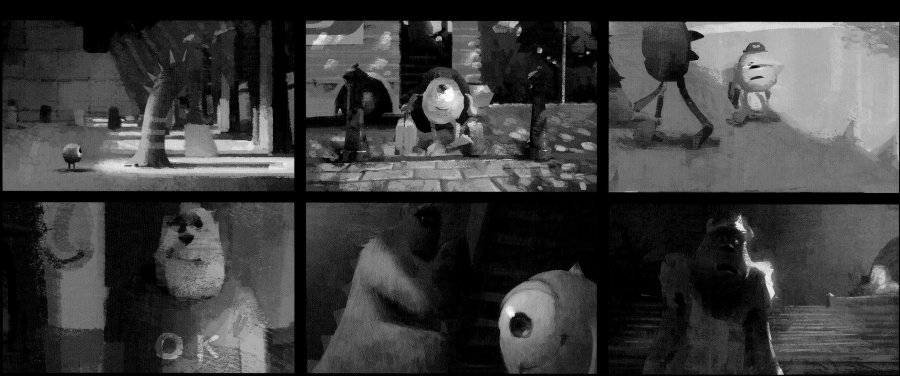

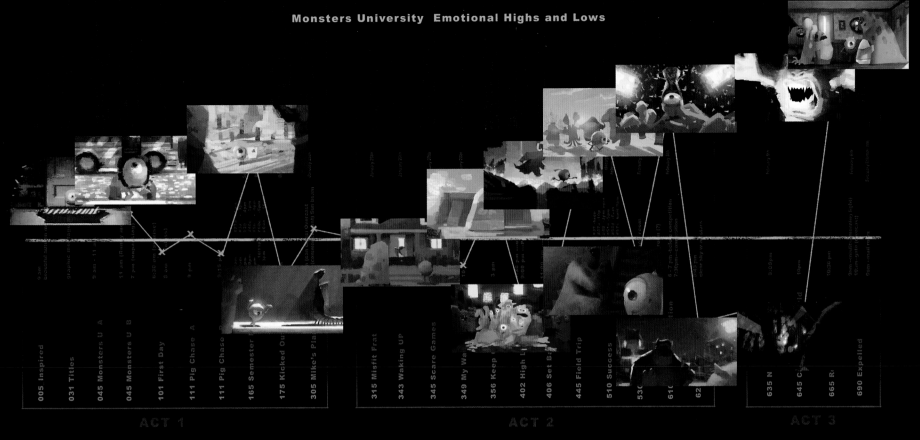

Dice Tsutsumi | digital | 2012

Dice Tsutsumi | digital | 2012

Making beautiful pictures is not hard, especially with the talented crew on this film and at the studio. The most important and difficult thing to do is to really, truly, be able to help the story—not just on a scene-by-scene or sequential basis, but to support the arc of the entire film visually. The camera and lighting DPs, production designer and art directors met with Dan [Scanlon] every week throughout production to specifically talk about the cinematography in the film. In these meetings, we'd discuss color, light, camera—everything to support the emotional beats. It was great to collaborate with Jean-Claude [Kalache] and Matt [Aspbury] and to bring their thinking into the color-script so that we were all working towards the same goal. Despite the story constantly shifting and evolving, the visual language of the film stayed fairly consistent. We even created an "emotional arc chart" upfront, to help us not lose track of the big picture.
—Dice Tsutsumi, shading and lighting art director

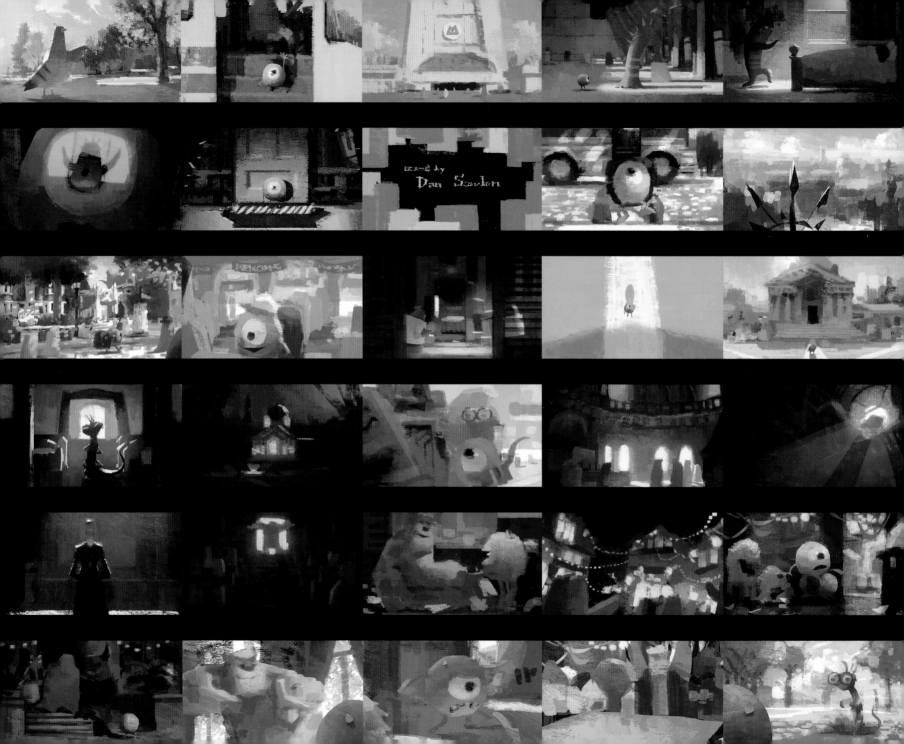

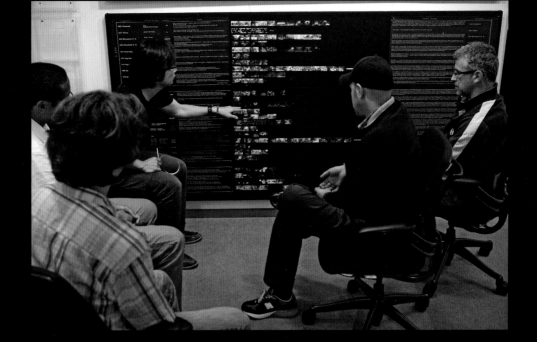

Dice's colorscript has been an incredible learning experience for me during the development of this film. It's a perfect companion to the production design; it's an integral part of the emotional storytelling of the film. Nothing is arbitrary when it comes to his color and light sensibilities. Color can be very personal and difficult because everyone has their own thoughts and ideas about it. Dice's colorscript is sensitive and aware of this. It accentuates the storytelling with a rhythm of lights and darks—as a character is introduced, or a character's arc changes, the light and the color support those changes. The look of this film wouldn't be what it is without his lighting and color choices.
—Ricky Nierva, production designer

On Monsters University we implemented a brand-new technology called Global Illumination that helped unify our lighting and make everything— characters' hair, faces, and skin—look richer. Shadows are more colored, textures more alive, everything feels juicier. Characters also feel more grounded in their environment; integrated in a much better way.
—Jean-Claude Kalache, lighting supervisor

There are a lot of separate groups of super talented people who make our film, having different discussions in opposite corners of the campus. These people are focused on making every pixel of this film as great as it can be. It's easy, though, to lose sight of the big picture. The color script is the emotional "big picture" road map that helps to coordinate and stimulate conversations between these amazing groups of people and to keep us honest and true to our story and the director's vision.
—Robert Kondo, sets art director

For the colorscript on Monsters University, Dice and I worked very closely over the two-plus years of production to sync up how the lighting and camera work could best compliment one another throughout the film. There are several key sequences in the movie where we had to carefully orchestrate the lighting with the staging of the characters and the lens choices to achieve a specific dramatic/emotional effect. For me and my team, it was incredibly beneficial to be thinking about and planning for lighting this early in the layout process so that no big cheats or fixes had to be done after the fact. This collaboration only helped us to unite the film visually.
—Matt Aspbury, layout supervisor

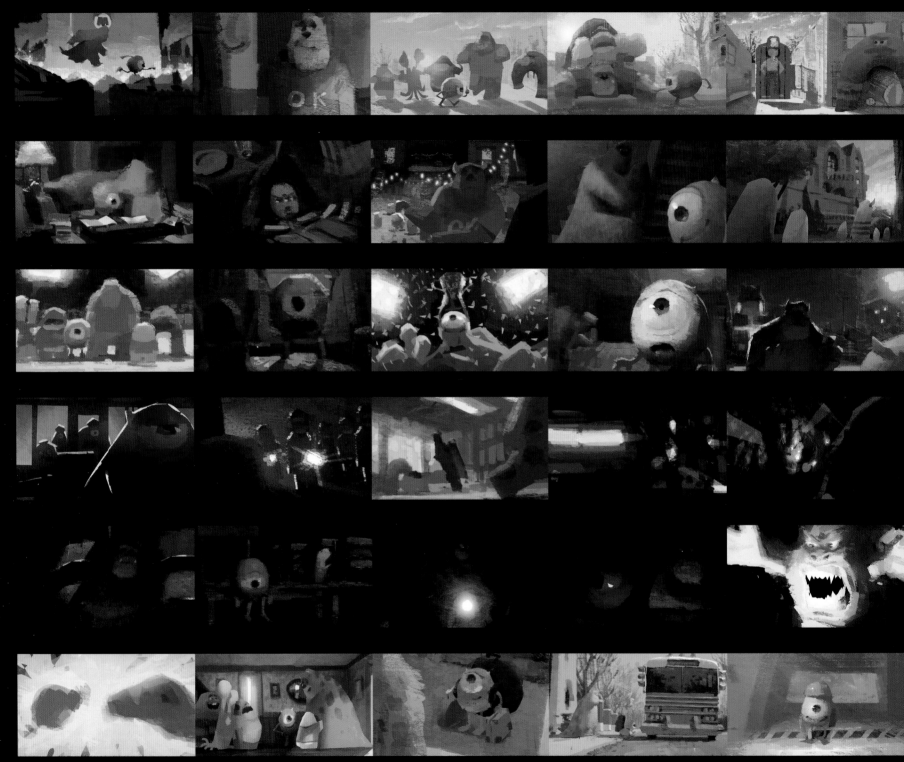

Dice Tsutsumi | digital | 2012

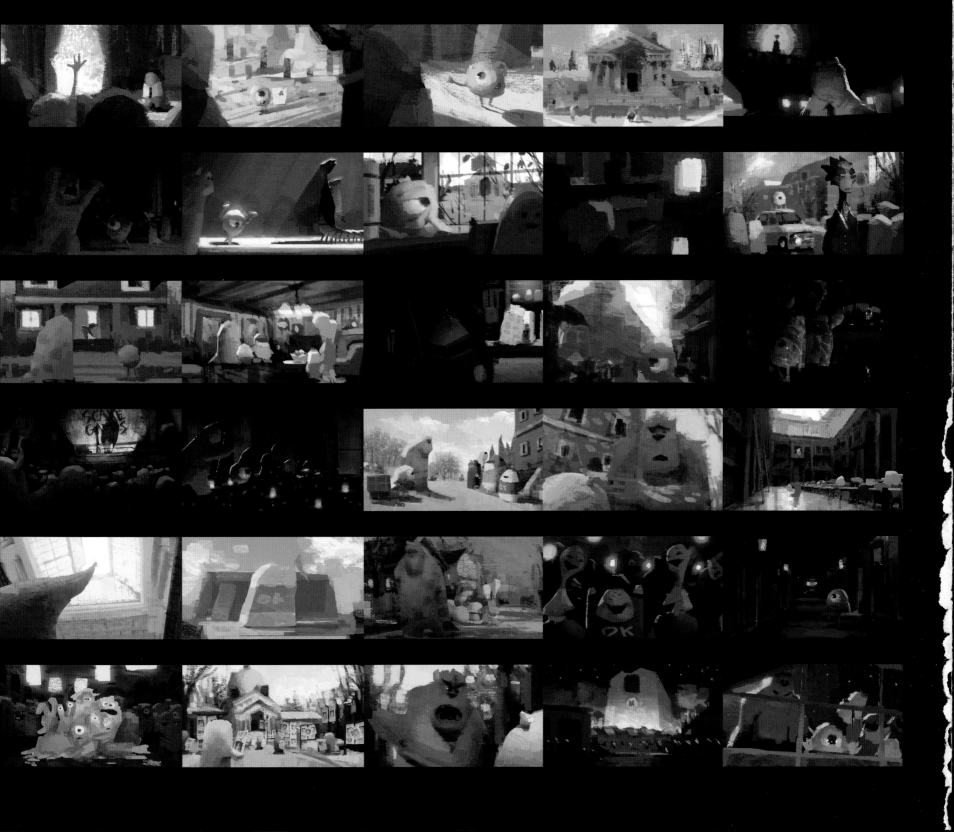

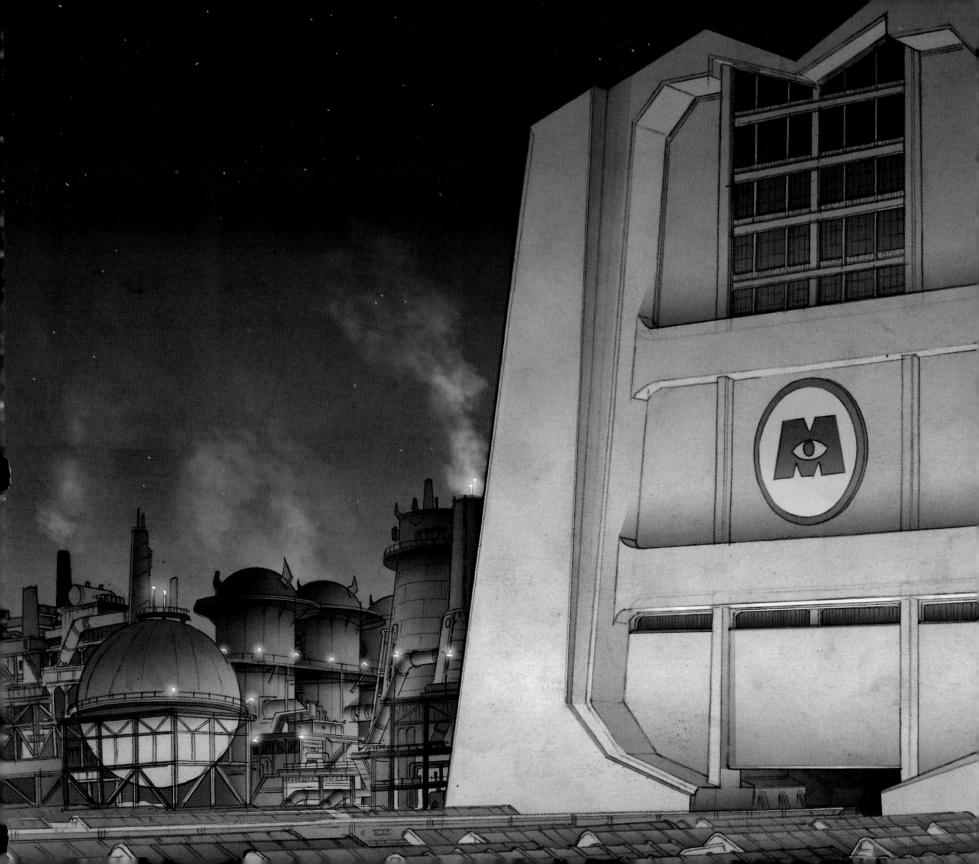

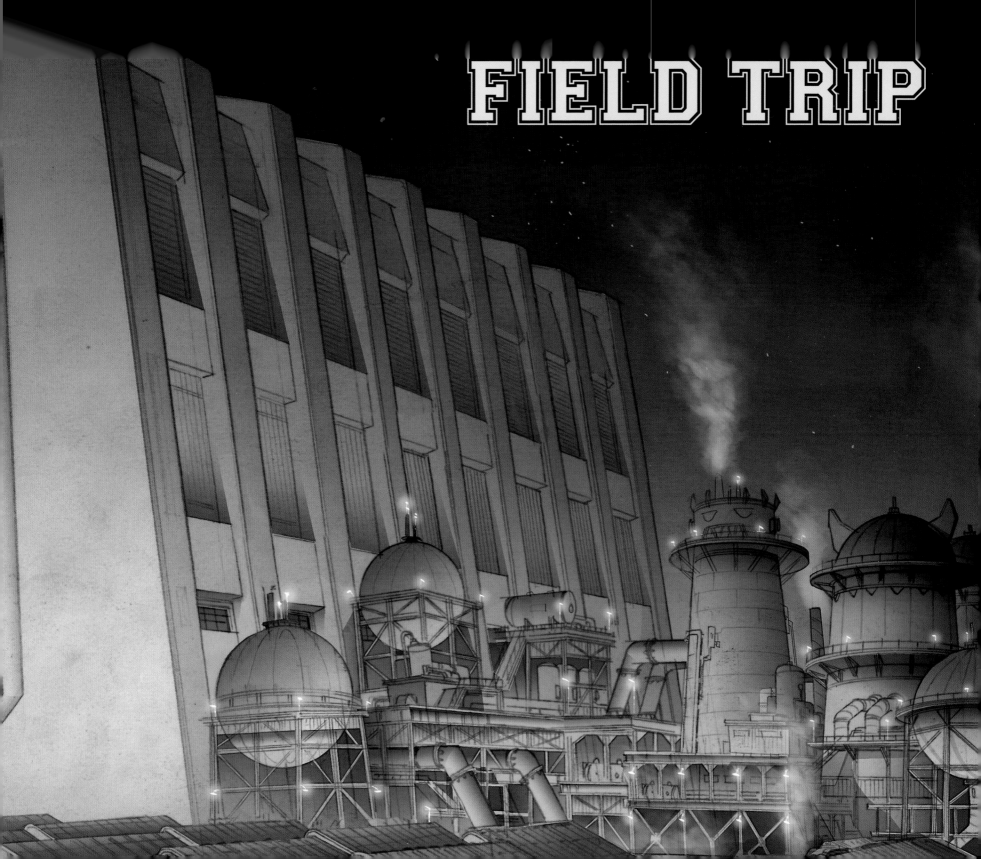

Recalls Dan Scanlon, "At some point I remember somebody pitching the idea of, what if these guys went [to Monsters Incorporated itself] and actually looked at their dream? It's such a big part of being in college and wanting to do something—the hero worship of the people that get to do it. So we loved this idea that they go and see Scarers at work, and we loved the idea that they break in [to do it], just because it's a very college-y thing to do." The mood of the sequence, says story artist Brian Fee, is perfect for that point in the film. "It really marries this prequel university world, and these younger characters, to the original movie. The tone shifts at that moment when they go peek through the window, and you get a little microcosm of the first movie. Whether they realize it or not, it's the first time [Mike and Sulley] start to see that they both want the same things."

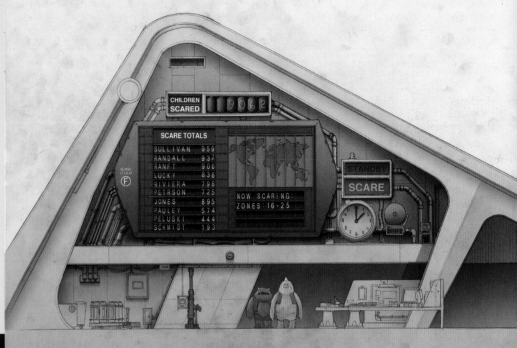

Kristian Norelius | pencil | 2011

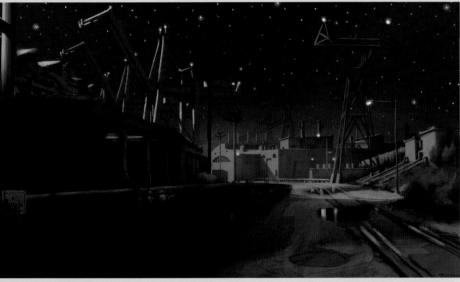

Jennifer Chang | digital | 2011
pages 136–137: **Kristian Norelius** | pencil | 2011

We wanted to make Monsters Incorporated feel older in this film, since it takes place about twenty years before the first movie. Instead of being a bank of televisions, the leaderboard is one of those old flip displays you used to see in train stations. And the door stations are chunkier and fatter. It reflects the way technology gets smaller over time—cell phones in the '80s were big bricks compared to the phones we have now.
—Ricky Nierva, production designer

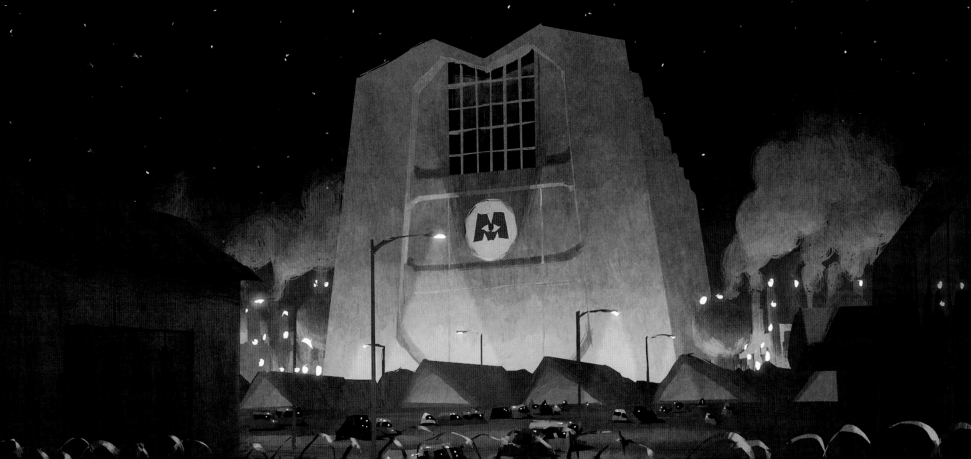

facilities yet, that that would have taken place between this movie and the first one. So that's why the first MI looked very design-y and very clean and nice. We wanted this MI to look older, with smoke and more detailed piping.
—Kristian Norelius, sketch artist

Dice Tsutsumi | digital | 2011

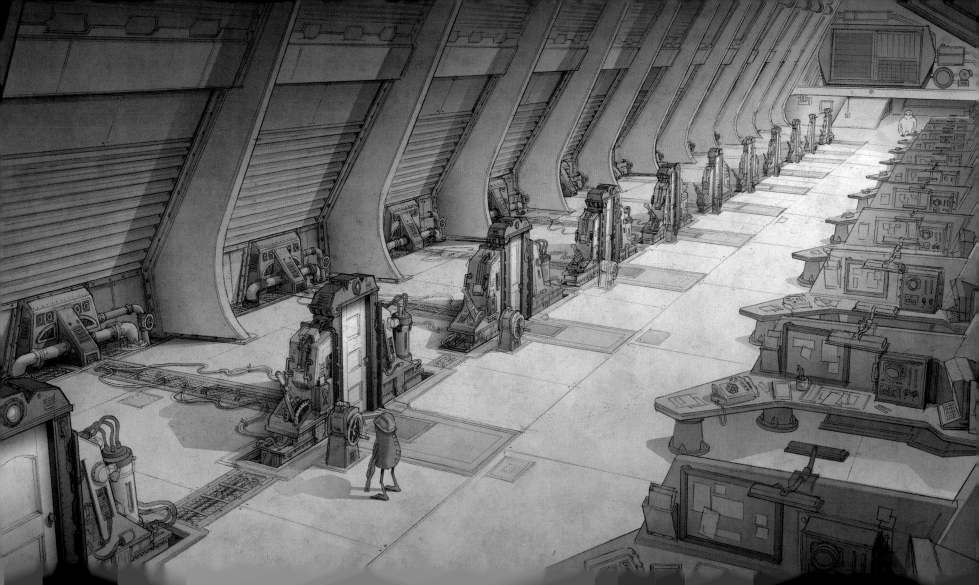

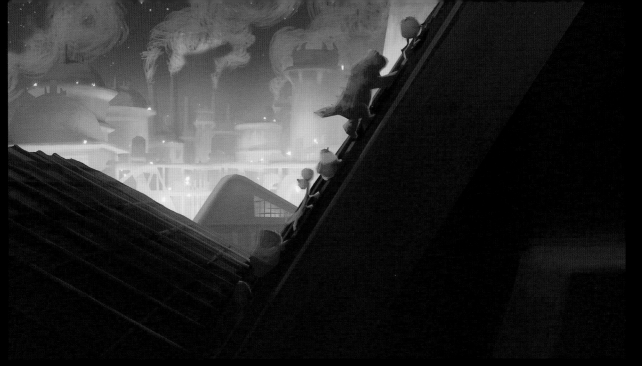

Shelly Wan | digital | 2012

1 2 3 4 5 6 7 8

MONSTERS INC.

WE SCARE Because **WE CARE**

WE SCARE

WE CARE

MONSTERS INC.

SAFETY FIRST

SCARE SCHEDULE

WE SCARE BECAUSE WE SCARE

IT'S YOUR JOB TO
1 2 3
4 5 2
KNOW YOUR DOOR

THIS STATION SCARING
20 DAYS ACCIDENT FREE

SCARERS ONLY BEYOND THIS POINT

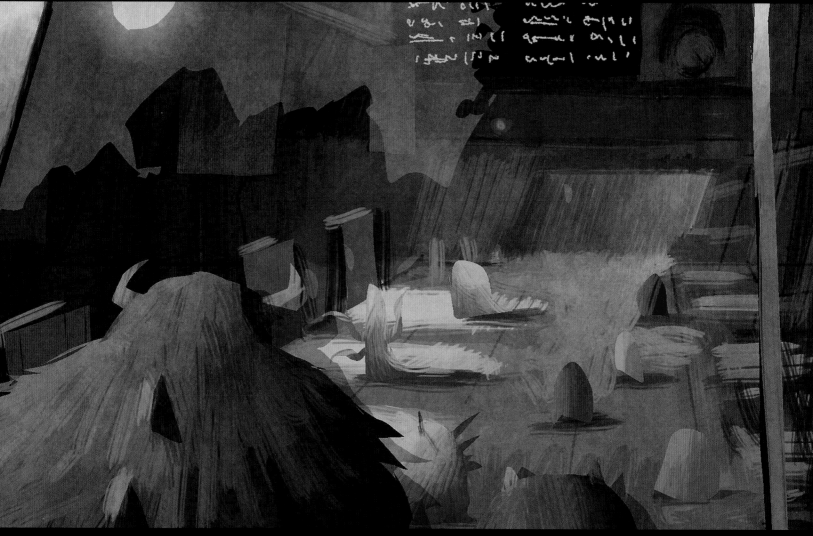

tsumi | digital | 2010

*The Oozma Kappa field trip to Monsters
Incorporated is Mike taking his friends to
his "birthplace," to the ground zero of where
he fell in love with scaring, his church.*
—Dan Scanlon, director

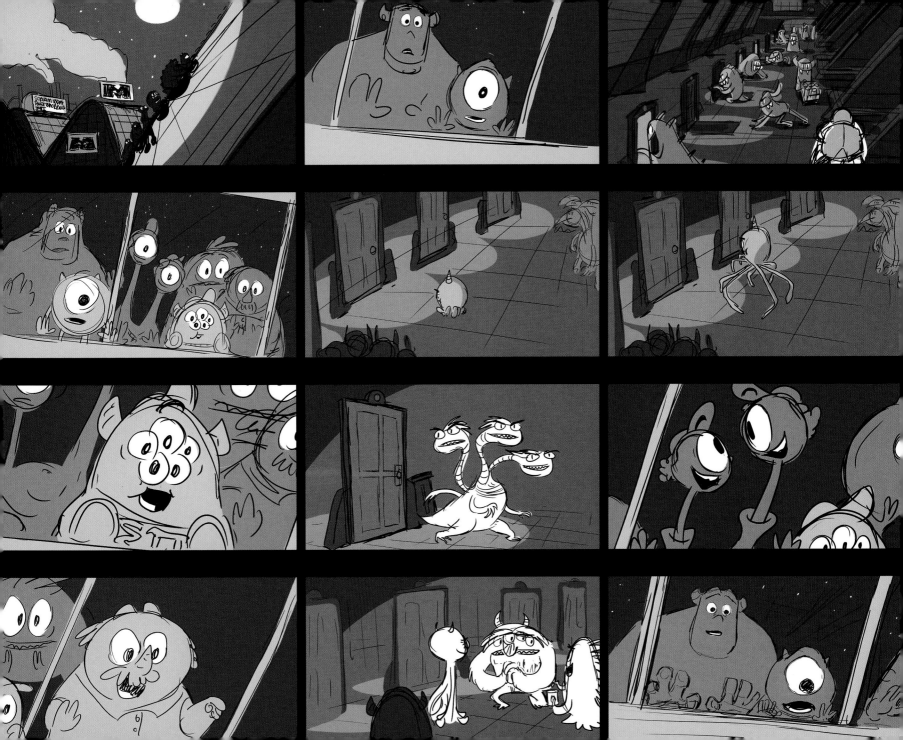

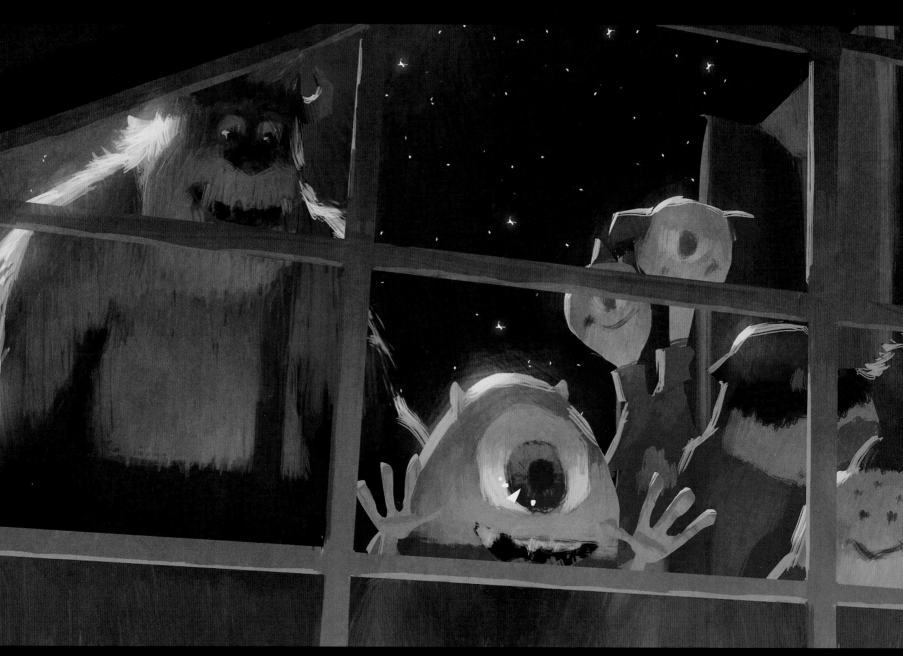

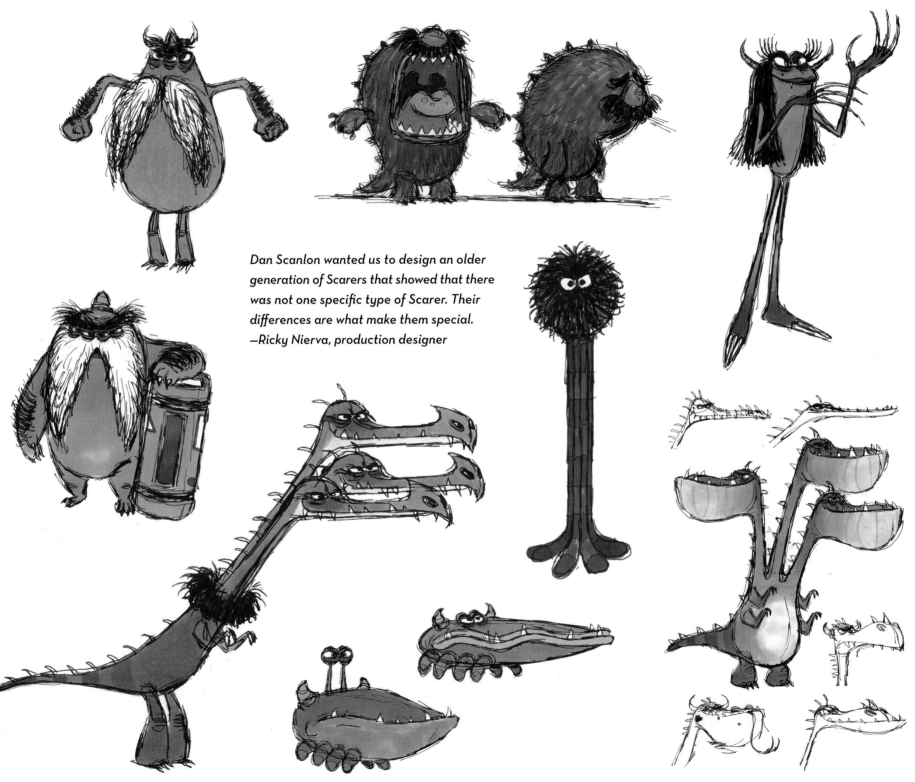

Dan Scanlon wanted us to design an older generation of Scarers that showed that there was not one specific type of Scarer. Their differences are what make them special.
—Ricky Nierva, production designer

Chris Sasaki | pen, marker | 2011

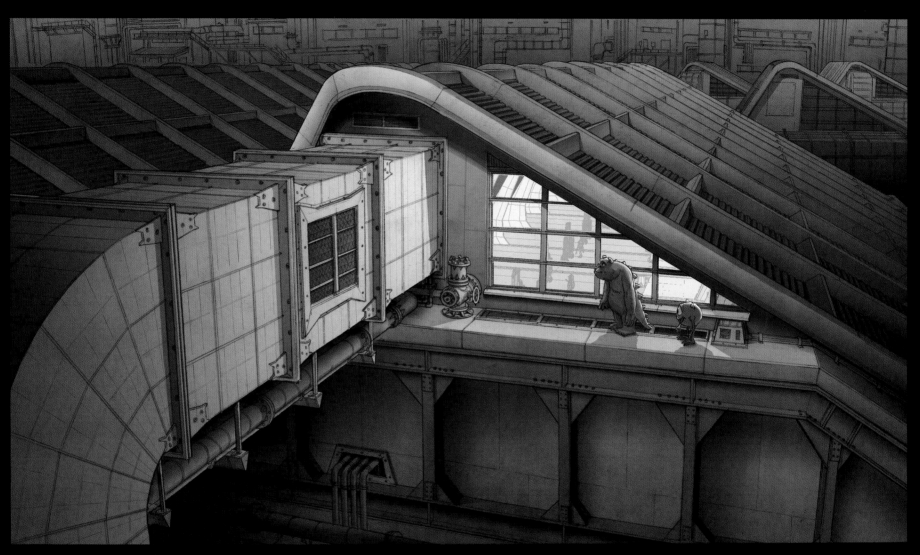

Kristian Norelius (design), Robert Kinkead (pre-visualization) | digital | 2011

Dice Tsutsumi | digital | 2011

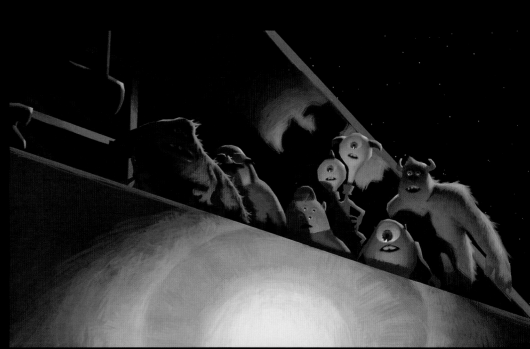

Shelly Wan | digital | 2012

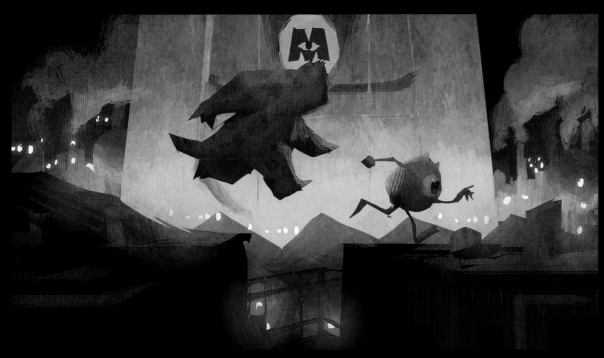

Dice Tsutsumi | digital | 2011

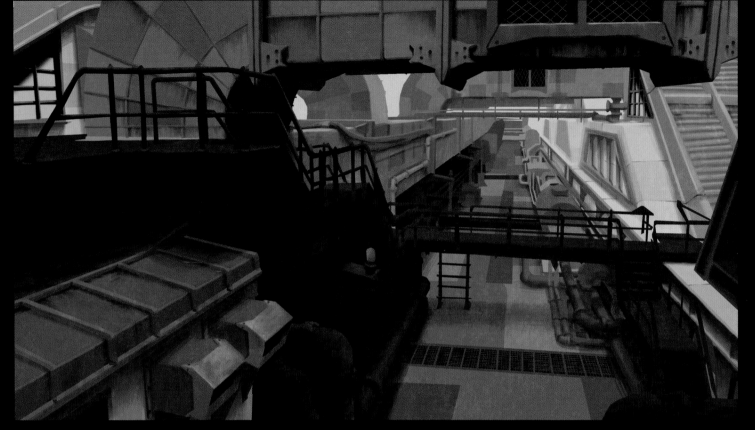

Shelly Wan | digital | 2011

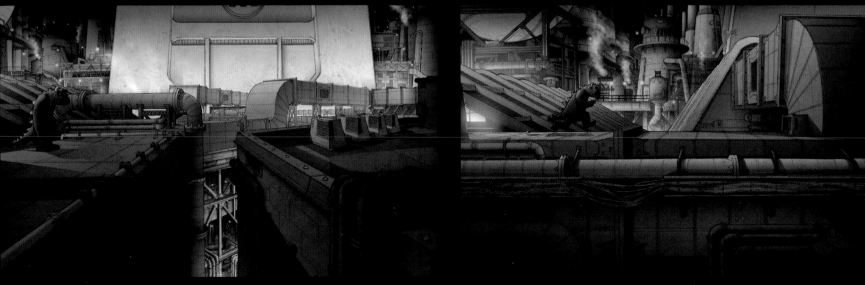

Kristian Norelius (design), **Robert Kinkead** (pre-visualization) | pencil, digital | 2011 **Kristian Norelius** (design), **Robert Kinkead** (pre-visualization) | pencil, digital

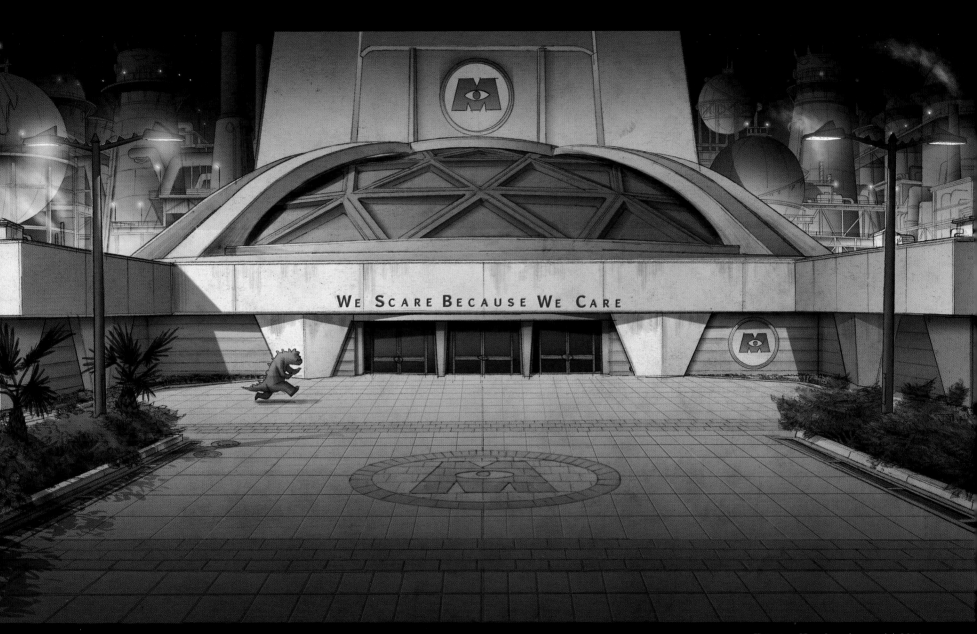

WE SCARE BECAUSE WE CARE

Kristian Norelius | pencil | 2011

CAMP TEAMWORK

Some initial versions of the story had Mike and Sulley getting stuck in the human world early on in the film. But, says story artist Matthew Luhn, the creative team soon realized that "people don't want to spend the whole film just watching our characters in the human world. You want to see them at whatever a monster college is. That's the fun of the movie." The human world was perfect, however, for the film's climax. As story supervisor Kelsey Mann explains, "What Mike is really good at is lifting up others around him, and becoming a great coach, and making Sulley be a hundred times better than he would have been on his own. They're really a team. So we thought, Have them learn that through a real flesh and blood experience in the human world. Story artists Dean Kelly and James Robertson did some research as to where this could happen, and they came up with the idea of doing a horror movie twist and having it take place at a sleepaway camp—because the campers are the really scary ones to Mike and Sulley."

Dice Tsutsumi | digital | 2012

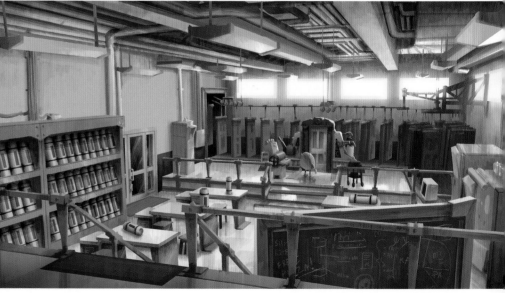

Jennifer Chang | digital | 2012
pages 150–151: Jennifer Chang | digital | 2012

Paul Abadilla | digital | 2011

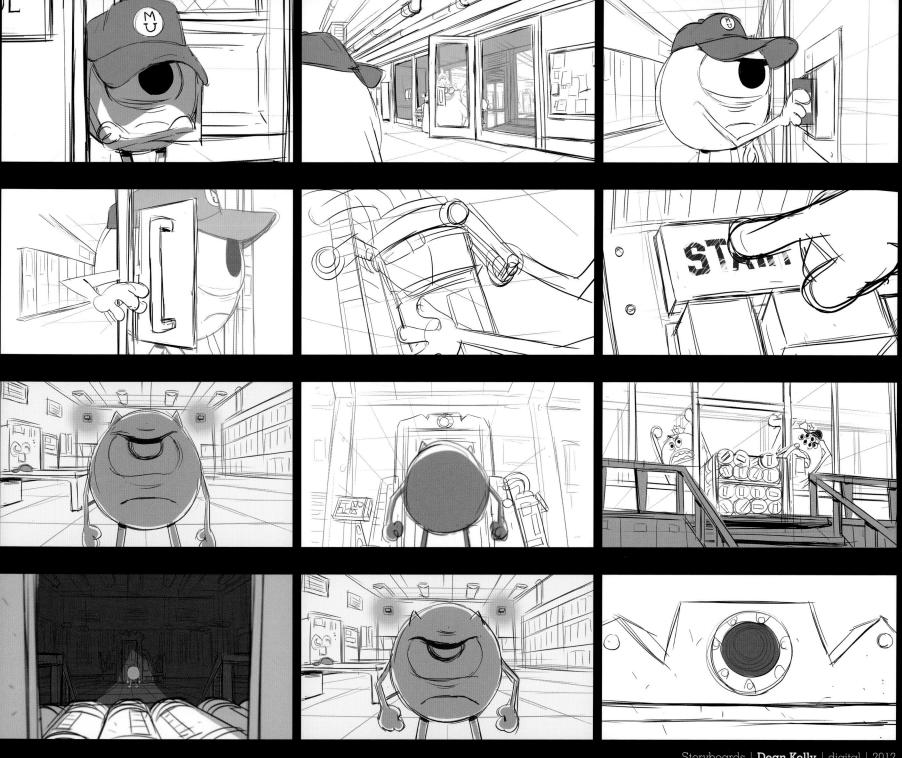

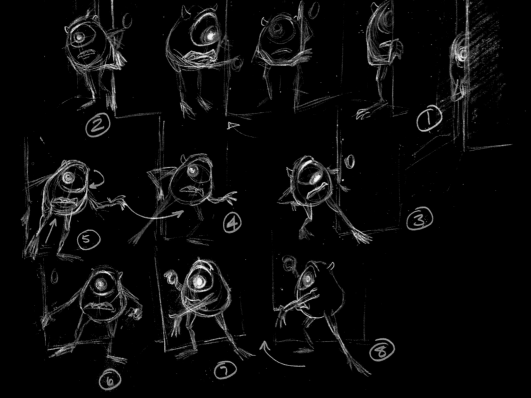

Don Crum | pencil | 2011

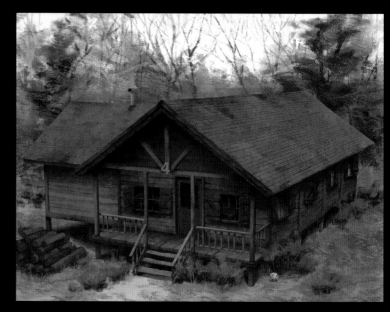

Shelly Wan (painting), **Nelson Bohol** (design) | digital | 2011

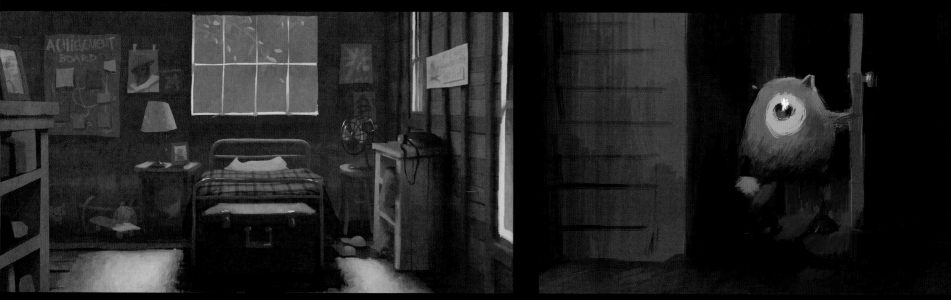

Shelly Wan | digital | 2011

Jennifer Chang | digital | 2012

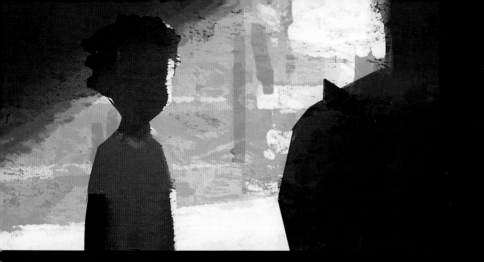

Dice Tsutsumi | digital | 2012

We liked the idea that when a monster goes into the human world, it's their version of a horror movie. That's part of why we set the end of the film at a camp, to get that classic '80s horror movie feel. So one of the things we did was make everything in the human world look brittle, a little thin—partly to make the monsters look bigger, but also to make things look scarier or creepier or jagged. We also sucked out all the color and kept things dark, just to play that contrast against the big, bulky, colorful monster world.
—Dan Scanlon, director

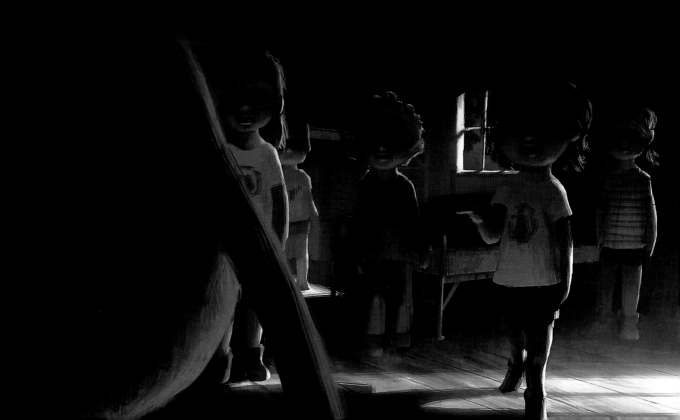

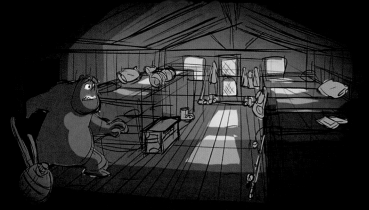

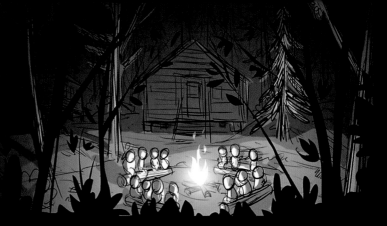

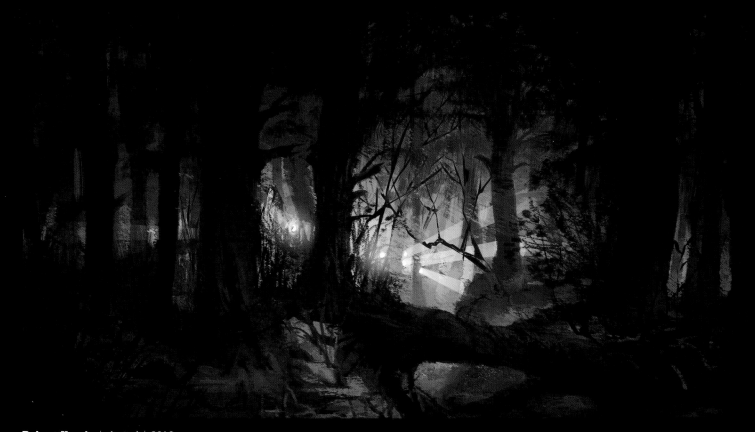

Robert Kondo | digital | 2012

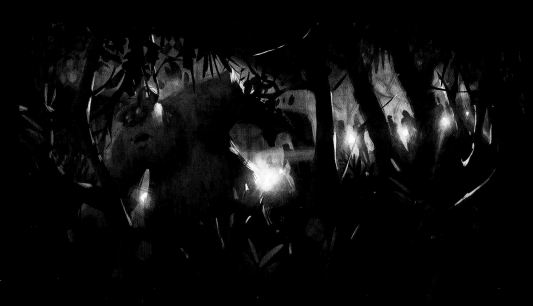

Dice Tsutsumi | digital | 2010

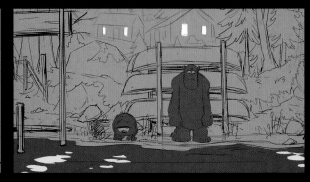

Storyboards | **Dean Kelly** | digital | 2011 & 2012

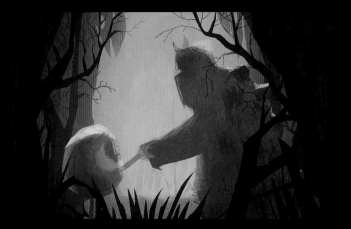

We always knew that, at the end, Mike's coaching would help Sulley get them both back to the monster world, because that's their relationship in the first film: Sulley's the muscle, and Mike's the brains. So we had to design the film to get there. It was a challenge to get them there in an unexpected way.
—Pete Docter, executive producer

Dice Tsutsumi | digital | 2010

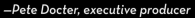

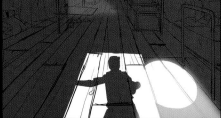

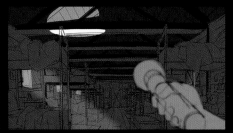

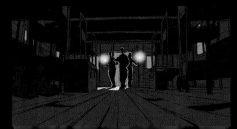

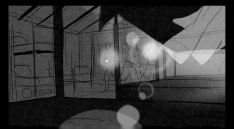

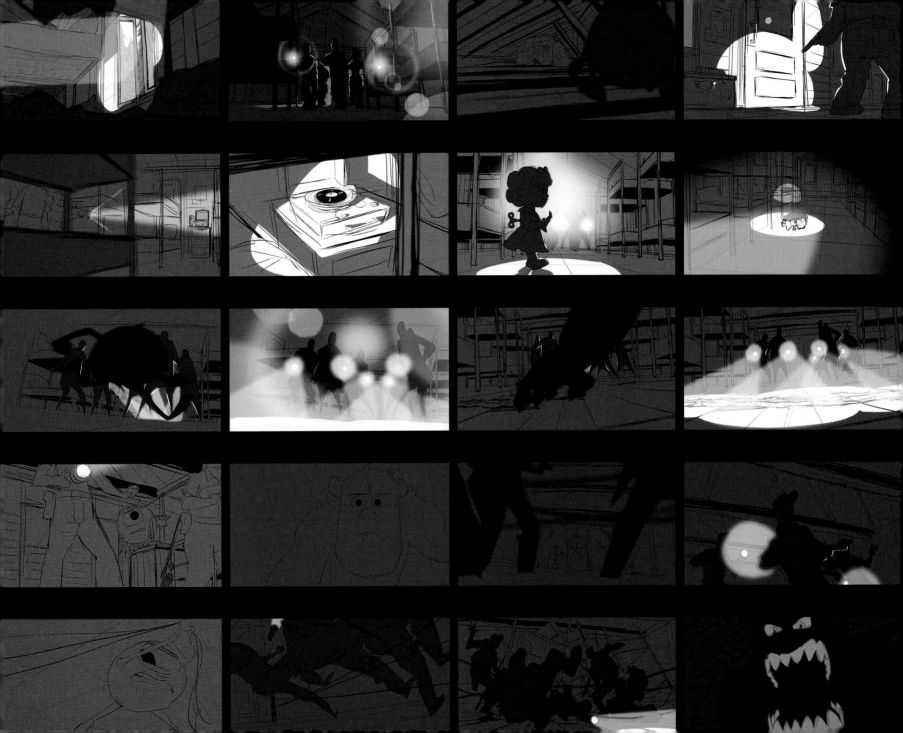

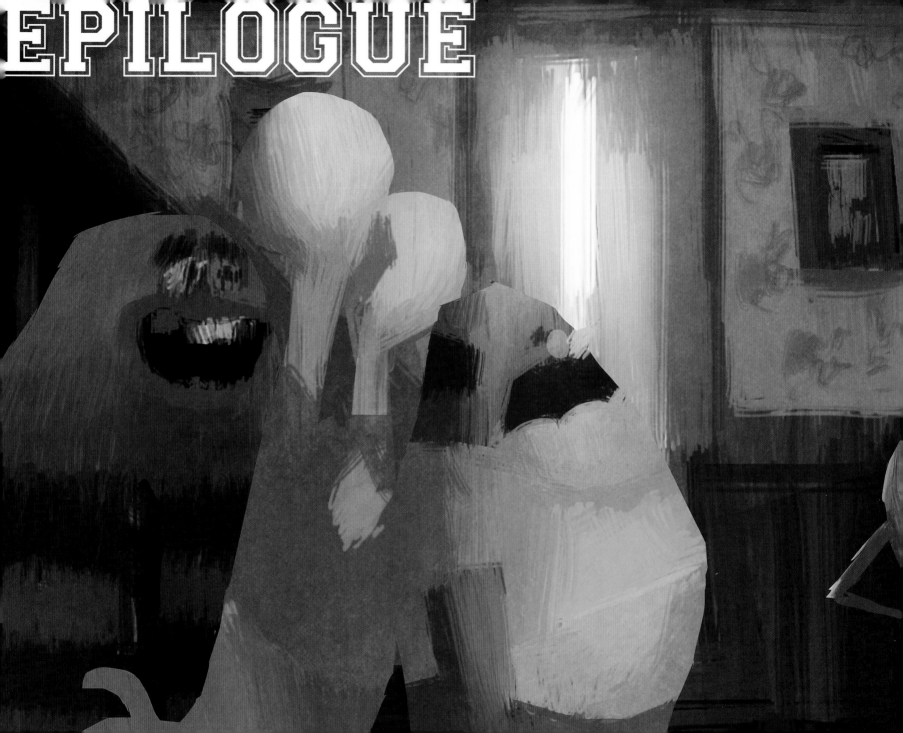

EPILOGUE

Producer Kori Rae recalls that when Dan Scanlon decided that the film was really going to be about Mike Wazowski and his story, "he was really attracted to the idea of how we deal with failure. What happens when what we thought we were going to do or who we were going to be changes, and we end up in a totally different place? When you ask someone How did you get where you are today? very seldom do you hear 'I went to school, studied what I planned on studying, and then went immediately into that field of work.' This film delves into that in a really powerful way."

As Scanlon explains, "Mike basically realizes he needs to let go of what he thinks he has to be in order to be great, so that he can make room for what truly makes him great. That is the real story of the film. His friendship with Sulley comes out of that, and Sulley changes and becomes a better person because of that." As it so happens, this arc is not so different from the arc of the story process itself. "You fall in love with these things that you think the story is about, and then you realize the story is about something else," says Scanlon. "Then you have to let go of those things, and it's painful a lot of the time. But it's always for the best."

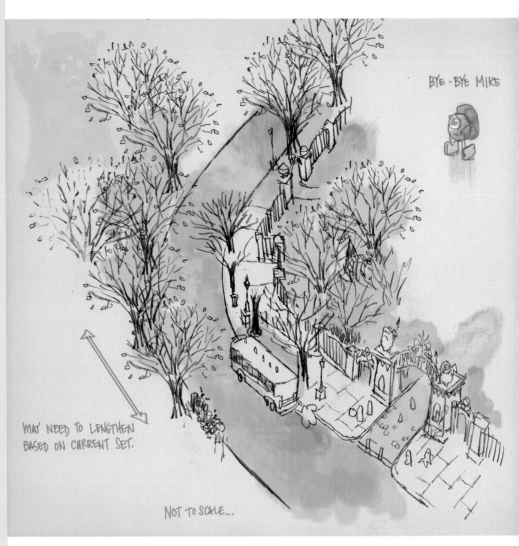

BYE-BYE MIKE

MAY NEED TO LENGTHEN BASED ON CURRENT SET.

NOT TO SCALE...

Robert Kondo | digital | 2012

James Robertson | digital | 2011
pages 160–161: **Dice Tsutsumi** | digital | 2011

Monsters University celebrates the best of what college is about—not only the academic side, but the fun side, all the different and unique things that college life can offer. It's a new world for these students, who are finding themselves and finding out who they are.
—Ricky Nierva, production designer

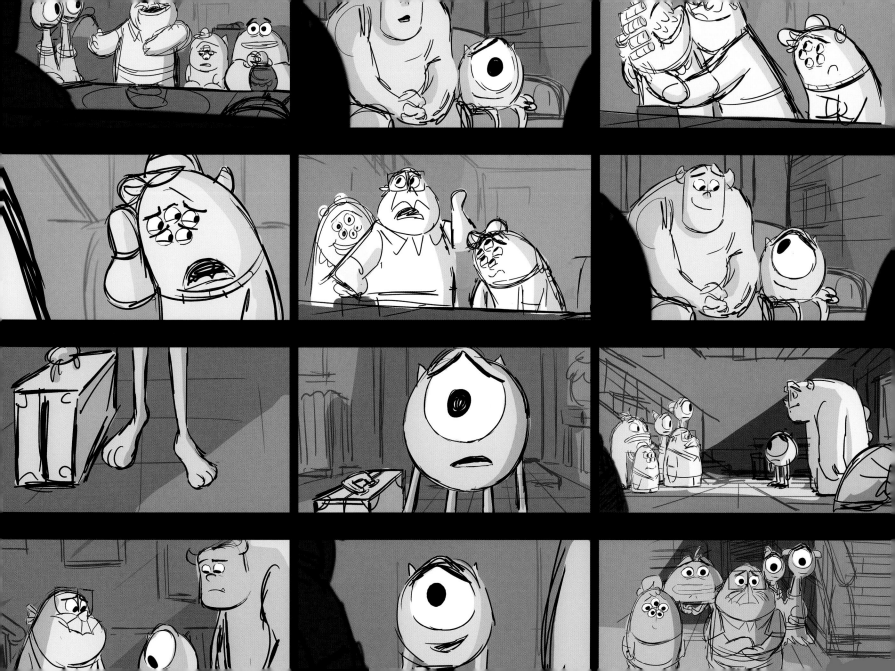

When we first had the idea [of a prequel set in college], we thought, Oh, this'll be great! John was sold immediately on the fun of college humor, and we'd hit on this idea of "when one door closes, another opens." That was a thematic element that came up pretty early on. We've all grown up on the message "You can do whatever you want if you just try hard enough and dream big!"—but it doesn't always happen that way.
—Pete Docter, executive producer

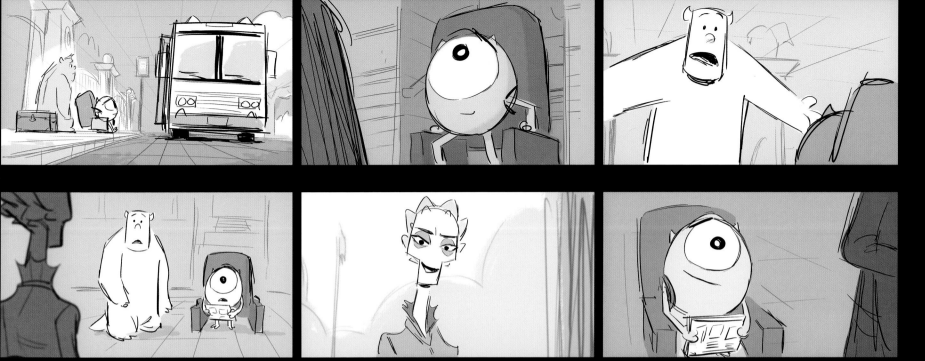

Storyboards | **Kelsey Mann** | digital | 2012

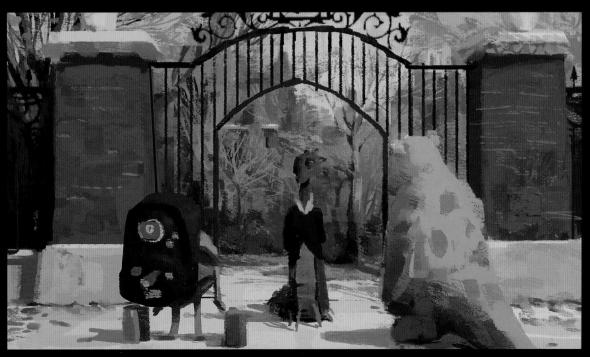

Robert Kondo | digital | 2012

Kelsey Mann | digital | 2012

ACKNOWLEDGMENTS

Thank you to the filmmakers of Monsters University whose work and words fill these pages and spring to life on our screens, particularly Dan Scanlon, Kori Rae, Ricky Nierva and the amazing art department, Kelsey Mann and the superlative story crew, and all those who took the time to speak to me for this book. Special thanks to Nicole Grindle, David Park, Nick Berry, Rachel Raffael, Judy Jou, Duncan Ramsay, Mike Capbarat, Anthony Kemp, Paul Washburn, Lee Rase, Margo Zimmerman, Kiera McAuliffe, and Amy Ellenwood, and to Pete Docter and John Lasseter for their support.

LeighAnna MacFadden was kind enough to bring me to this project, Emily Haynes deftly led the way, and the multitalented Kiki Thorpe generously and gracefully made it all possible. For their tireless efforts, many thanks to Kelly Bonbright, Bowbay Pellicano, and Danka Buchal of Pixar Publishing, Courtney Drew, Neil Egan, Beth Steiner, Lia Brown, and Becca Boe of Chronicle Books, Glen Nakasako of Smog Design, and Taylor Jessen. On a personal note, I'm deeply indebted to Yvonne Paik and Tae Paik. And finally—thank you to Mike and Dario, my home team.

—Karen Paik

Matthew Luhn | digital | 2010